PAUL KLEE

THE NATURE OF CREATION

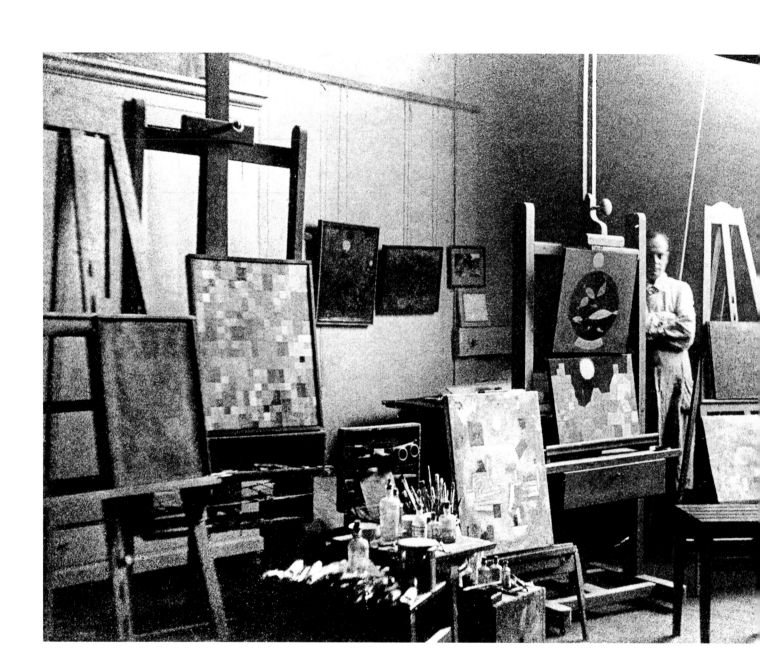

PAUL KLEE

THE NATURE OF CREATION | WORKS 1914–1940

ROBERT KUDIELKA | WITH AN ESSAY BY BRIDGET RILEY

HAYWARD GALLERY IN ASSOCIATION WITH LUND HUMPHRIES

sbc

Published by the Hayward Gallery in association
with Lund Humphries on the occasion of the exhibition
Paul Klee: The Nature of Creation organized
by the Hayward Gallery, London, 17 January – 1 April 2002

Public Programmes and Marketing campaigns generously
supported by the Stanley Thomas Johnson Foundation
Catalogue and lenders' dinner generously supported by Presence Switzerland
Transport generously supported by Pro Helvetia

**STANLEY THOMAS
JOHNSON FOUNDATION**

Exhibition curated by Robert Kudielka and Bridget Riley
Exhibition organized by Suzanne Cotter, assisted by Jessica Fisher

Catalogue designed by Peter Campbell
Printed in England by Westerham Press
Front cover: *Städtebild (rot/grüne Accente)*, 1921 (detail) /
Picture of a City (Red-Green Accents) (cat. 30), Staatsgalerie Stuttgart
Frontispiece: Paul Klee in his studio, Weimar, 1926
Klee Family Estate. Deposited at the Paul-Klee-Stiftung, Kunstmuseum Bern
Photo: Felix Klee

Published by Hayward Gallery Publishing, London SE1 8XX, UK, in association with Lund Humphries, Gower
House, Croft Road, Aldershot, Hants GU11 3HR and 131 Main Street, Burlington, VT 05401-5600, USA

Lund Humphries is part of Ashgate Publishing. www.lundhumphries.com

© Hayward Gallery 2002
Essay by Robert Kudielka © Robert Kudielka 2002
Essay by Bridget Riley © Bridget Riley 2002
Artworks © DACS 2002 (unless stated otherwise)

ISBN 1 85332 224 5 (paperback) (Hayward Gallery edition)
ISBN 0 85331 853 0 (hardback) (Lund Humphries edition)

A catalogue record for this book is available from the British Library
Library of Congress Control Number: 2001096265

CONTENTS

PREFACE

In early 2000 I received a telephone call from the artist Bridget Riley, who asked whether I ever thought about Paul Klee. It turned out he was much in her mind and, she told me, in that of Robert Kudielka, Professor of Aesthetics and Philosophy of Art at the Universität der Künste, Berlin, who had given a series of twenty-four lectures on Klee, enquiring into the coherence of his approach. They both had an idea they wanted to share and, within a few days, the Hayward's Head of Exhibitions, Martin Caiger-Smith, and I were in Bridget's studio, being treated by Robert and Bridget to a slide presentation of Klee's work. It showed us the Klee we knew — one of the most imaginative artists of the twentieth century; the playfulness and enchantment so readily associated with his work were evident but surprisingly, and more to the fore, was a rigorous and analytical artist. Bridget and Robert somehow put us inside Paul Klee's head, revealing how he moved unceasingly and deliberately between abstraction and figuration through an intense engagement with the tools of picture-making — line, colour, tone, rhythm, balance. Klee's deliberate deployment of these means and his unparalleled experimentation with them created some of the most inspiring pictures of our time. This multi-track, formal analysis of Klee's work has provided a clear and, at the same time, rich and complex set of directions for the exhibition at the Hayward Gallery.

Klee has a distinguished history of exhibitions in Britain, starting with his solo exhibition at the Mayor Gallery, London in 1934 and including, among others in the intervening years, a retrospective at the Tate Gallery in 1945-46, and a survey of late work drawn from the collection of Felix Klee presented at the Hayward Gallery in 1974-75. In the last fifteen years alone, two first-rate collections of his work have been shown here, the Berggruen Collection in 1989 at the Tate, and the Bürgi Collection in 2000 at the Scottish National Gallery of Modern Art. Each a delight to the eye, these occasions whetted appetites for a further, more considered look at Klee, his place within the development of twentieth century art, and his ongoing potential to influence.

That we are able to do this now owes, first and foremost, to the vision, understanding and passion which Robert Kudielka and Bridget Riley bring to the subject. Their curatorial collaboration endows this project both with a scholarly focus and an artist's eye. There can be no better acknowledgement of the originality and relevance of their approach to Klee than the overwhelming support their proposal received from the owners and guardians of Paul Klee's works. Our debt to Bridget and Robert for their erudition and acute judgement, their uncompromising selection and their willingness to champion the project on every front is immense. It has been incredibly rewarding to work with them, and we have no doubt their insights will equally reward everyone who comes into contact with the show, or encounters it vicariously through this publication.

No such exhibition is possible without the support of collectors. In the case of Klee, his works are central to the collections that hold them, are among the most frequently requested for loan, and are often fragile. We are therefore all the more indebted to the

museums and private collectors who have so generously, and often extraordinarily, agreed to lend major works on this occasion. Many will not be lent again in the foreseeable future due to openings of new buildings and displays planned by their owners.

We would especially like to thank the Paul-Klee-Stiftung in Bern for its willingness to lend an important number of works, and the Assistant Curator there, Michael Baumgartner, whose interest in our project from an early stage was an important source of encouragement, and who has given it his invaluable and unstinting assistance.

We are similarly grateful for the patient and thoughtful reception we received during the show's research and preparation stages from potential lenders and colleagues whose views broadened our thinking. Among those whom we would especially like to thank are, in New York, William S. Lieberman, Department of 20th Century Paintings and Drawings, Metropolitan Museum of Art, and his Associate Curator, Sabine Rewald; Lisa Dennison, Deputy Director and Chief Curator, Guggenheim Museum; Glenn Lowry, Director, Kirk Varnedoe, Chief Curator, Painting and Sculpture, and Gary Garrels, Chief Curator, Department of Drawings, The Museum of Modern Art; in Germany, Heinz Berggruen; Peter-Klaus Schuster, Director, and Angela Schneider, Deputy Director, Staatliche Museen zu Berlin; Ulrich Krempel, Director, Sprengel Museum, Hannover, and Curator of Paintings and Sculpture, Dietmar Elger; Helmut Friedel, Director, Lenbachhaus, Munich; Carla Schulz-Hoffmann, Director General, Bayerische Staatsgemäldesammlungen, Munich, and Curator, Joachim Kaak; Jean-Hubert Martin, Director, museum kunstpalast, Düsseldorf; Armin Zweite, Director, Kunstsammlung Nordrhein-Westfalen, Düsseldorf; Christian von Holst, Director, Staatsgalerie Stuttgart, and Head of Department of Prints, Drawings and Photography, Ulrike Gauss; in Switzerland, Ernst Beyeler; Bernhard Mendes Bürgi, Director, Kunstmuseum Basel, his predecessor Katharina Schmidt, and Christian Müller, Chief Curator, Kupferstich-kabinett; in France, Alfred Pacquement, Director, and Isabelle Monod-Fontaine, Deputy Director, Musée national d'art moderne, Centre Georges Pompidou, Paris.

We would very much like to thank the Stanley Thomas Johnson Foundation for their generous support of this exhibition, particularly with our Public Programmes and marketing campaigns. Their assistance has made a significant contribution to our work, for which we are most grateful.

Presence Switzerland has supported this publication and the lenders' dinner. We extend our thanks particularly to the Swiss Ambassador, HE Bruno Spinner, Cultural Counsellor, Wolfgang Amadeus Bruelhart, and Attaché Cultural Affairs, Anne-Marie Aeschlimann, who have worked closely with us in London, and Yves Morath, Deputy Secretary of the Co-ordinating Commission for Presence Switzerland Abroad, in Bern, and, working alongside him, Dieter Borer.

Our thanks also extend to Pro Helvetia, whose support has helped with transport costs. We are pleased to have received additional assistance from All Nippon Airways for the transportation of works from Japan, and from ICI Paints, who have helped mix colours and kindly supplied paint for the installation.

Warmest thanks go to Paul Williams and Bert Rozeman of Stanton Williams Architects for their elegant and sensitive installation design. They have been wholeheartedly committed to bringing Klee's work to life in the Hayward's spaces, and Stanton Williams Architects have additionally given support to enhance aspects of the show's presentation.

Peter Campbell has fulfilled our hopes for a catalogue whose design does justice to the work of Paul Klee by clearly articulating it on the page. We are grateful to him and to the Hayward Gallery's Art Publisher, Linda Schofield, and Publishing Co-ordinator, Caroline Wetherilt, for their attention to every detail of production. We also appreciate the assistance Heidi Frautschi at the Paul-Klee-Stiftung in Bern has given us with the reproductions of Klee's work.

An exhibition of this ambition would not be possible without the effort and expertise of many people within the Hayward Gallery itself as well as those consultants with whom we have the pleasure of collaborating. In our Registrar's Office, Imogen Winter, Nick Rogers and Alison Maun have worked assiduously to arrange the transport and cover of loans. Conservator Bill Mackinnon has, as ever, extended due care. John Johnson and his team at Lightwaves, and the Hayward Gallery's Head of Operations, Keith Hardy, our Installation Manager, Mark King, and his crew have ensured the exhibition is presented to full effect. The Hayward Gallery's Head of Exhibitions, Martin Caiger-Smith; our Head of Marketing, Avril Scott and Helen Faulkner, Marketing Co-ordinator; Ann Berni, our Press Relations Manager and Arwen Fitch, Press Relations Co-ordinator; Felicity Allen, the Hayward's Head of Public Programmes, and Helen Luckett, Education Co-ordinator; Karen Whitehouse, our Head of Development, and Maggie Prendergast, our Corporate Development Manager, have joined forces behind the scenes to ensure the exhibition reaches and engages our public. My thanks go to them all for their creativity and commitment.

Finally, I would like to pay particular tribute to the Hayward Gallery's Exhibitions Curator, Suzanne Cotter, who, with her assistant Jessica Fisher, has worked with devotion, quiet tenacity and great skill to make Robert and Bridget's vision a reality. Together, and thanks above all to the superb works that will fill our walls, they bring to us a fresh, more profound and wonderfully pleasurable experience of Paul Klee.

Susan Ferleger Brades
Director, Hayward Gallery

ACKNOWLEDGEMENTS

In addition to those people mentioned in the preface, we would like to extend our sincerest thanks to the following individuals for their assistance, advice and encouragement:

Alice Allen; Doris Ammann; Francis Atterbury, Westerham Press; Ruth Berson, Director of Exhibitions, San Francisco Museum of Modern Art; Armin Bienger, Marlborough Fine Art, London; Clive Boon, ICI Paints; Maxine Burman, Christie's, New York; Sara Campbell, Director of AA, Norton Simon Museum, Pasadena; Lucy Clark, Mie Cooper, All Nippon Airways; Anne d'Harnoncourt, Director, Philadelphia Museum of Art; Philippe de Montebello, Director, Metropolitan Museum of Art, New York; Dinny Court, ICI Paints; Susan Davidson, Collections Curator, The Menil Collection, Houston; Carl Djerassi; Bernd Dütting, Galerie Beyeler, Basel; Roger J.H. Emery; Stefan Frey, Curator, Klee-Nachlassverwaltung, Bern; Elizabeth Gorayeb, Sotheby's, New York; Saburoh Hasegawa, Director, Aichi Prefectural Museum of Art, Aichi; Rob Henderson, All Nippon Airways; Susanne Kudielka; Eva Keller, Curator, Daros Services AG; Diana L. Kunkel; Irvin M. Lippman, Executive Director, Columbus Museum of Art; Leigh Markopoulos; Haito Masahiko, Aichi Prefectural Museum, Aichi; Gabriele Mazzotta; Pia Müller-Tamm, Chief Curator, Kunstsammlung Nordrhein-Westfalen, Düsseldorf; Norbert Nobis, Deputy Director, Sprengel Museum, Hannover; Hans Jürgen Papies, Sammlung Berggruen, Berlin; Meira Perry-Lehmann; Michael Bromberg Senior Curator of Prints & Drawings, The Israel Museum, Jerusalem; Alessandro Porro, Finarte, Milan; Jock Reynolds, Director, Yale University Art Gallery, New Haven; Raffaella Resch, Fondazione Antonio Mazzotta, Milan; Ned Rifkin; Isabel Ryan; Karsten Schubert; Sabine Schulze, Head of 19th and 20th Century Paintings, Städelsches Kunstinstitut und Städtische Galerie, Frankfurt; Sir Nicholas Serota, Director, Tate, London; Jonas Storsve, Curator, Musée national d'art moderne, Centre Georges Pompidou, Paris; Michael Taylor, Curator, Philadelphia Museum of Art; David Thomson; Aleksandra Todorovic, Sotheby's, London; Wolfgang Wittrock.

Susan Ferleger Brades
Director, Hayward Gallery

PRESENCE SWITZERLAND FOREWORD

Presence Switzerland's purpose is to enhance Switzerland's presence around the world. More specifically, Presence Switzerland wishes to increase general knowledge and understanding of Switzerland abroad.

It aims to portray an authentic, representative and vibrant picture: for example, Switzerland's varied linguistic and cultural landscape, its humanitarian tradition and the direct influence of the Swiss people in political decision-making as well as excellence in education.

In the year 2002, declared by the United Nations to be the International Year of Mountains, Switzerland could not have chosen a better moment to strengthen its close relationship with the United Kingdom than with the Hayward Gallery's presentation of *Paul Klee: The Nature of Creation.*

What better ambassador could one find than art to recall the ties of friendship that link Switzerland and the United Kingdom – a friendship that has been renewed by this exhibition.

This collaboration inaugurates a wide range of activities this year organized by Presence Switzerland that are inspired by the theme 'Dialogue across mountains'. As such, Presence Switzerland and the Swiss Embassy in the United Kingdom are proud to contribute to the success of this *Paul Klee* exhibition and congratulate the Hayward Gallery on mounting this wonderful event.

Joseph Deiss
Federal Counsellor
Head of Foreign Affairs

MAKING VISIBLE

BRIDGET RILEY

MAKING VISIBLE

BRIDGET RILEY

Influence is a rather vague term to describe the kind of debt one artist owes another. It can be a case either of straightforward appropriation, which is something every young artist does, even has to do, in one way or another, to get started at all; or a two-sided relationship in the sense that you recognize in another artist something that you have long been searching for without being able to identify or articulate the need. The discovery may relate to only one aspect of the other artist's work, but it will be central to you. In this way Paul Klee was of seminal importance to me because he showed me what abstraction meant.

I first found a clue to Klee's thinking in the *Pedagogical Sketchbook*, which was published while he was teaching at the Bauhaus, and later, in a more amplified form in *The Thinking Eye*, a posthumous collection of his writings. As anybody who has ever looked into these books will understand I could not find any systematic coherence in either of them. It was only much later that I learned the reason for this confusion. Apart from a few essays, *The Thinking Eye* is a compilation of the notes Klee had used in his teaching over many years and that he had altered, revised and augmented as he went along. Although, as a result, they have no real sequence in themselves, the lack of order did not diminish or deflect the attraction they held for me. In fact it had the opposite effect. The very dispersal of his insights made me aware of the recurrence of a few main points, the most important of these being the distinction between schematic or theoretical abstraction and Abstract painting.

In everyday language abstraction refers to the process by which one draws a generalized notion or formula from the particularities of real experience. Abstraction in this sense is the result of an intellectual effort that everyone makes in order to cope with everyday experience. For instance, if I say 'tree' – you have only a word, but it will stand for trees of all sorts, for oaks, poplars, willows, firs, names which in turn are minor abstractions of the infinite variety of real trees. But in visual art this is not the meaning of abstraction, although it has often been confused with it.

The rise of Abstract art, especially in the first half of the twentieth century was accompanied by abstracted images from nature, schematic figures and objects, all of which bear witness to the uncertainty of the terrain explored and to the inevitable bewilderment that surrounded the emergence of this new form of art. Klee was the first artist to point out that for the painter the meaning of abstraction lay in the opposite direction to the intellectual effort of abstracting: it is not an end, but the beginning. Every painter starts with elements – lines, colours, forms – which are essentially abstract in relation to the pictorial experience that can be created with them.

Klee's penetration may have been supported by the fact that he himself was not a rigorous abstract painter in the sense that Mondrian was. This may have given him the detachment that enabled him to accept that abstraction had always been at the root of the art of painting. Now that the novelty of Abstract art has worn off it is not so difficult to see that Vermeer is more of an abstract painter than many avowed 'abstractionists'. The only really 'new' development of the twentieth century was that the abstractness of picture-making rose to the surface, literally and metaphorically. This was not the result of any wilful decision on the part of artists, but of the historical process in which painting's traditional role of serving a common language of social and religious imagery fell away.

Klee was not, of course, the only painter to be affected by this huge cultural schism. Matisse, Picasso, Braque, Kandinsky and Mondrian all responded to it in their different ways. The awareness of the crisis was deep and widespread and, of all art forms, painting took the lead and followed the most courageous paths. Even so, Klee is unique in that he demonstrated more fully that the elements of painting are not just means to an end, but have distinct characteristics of their own. A huge part of *The Thinking Eye* consists of very precise analyses of what lines, colours and forms *do* once they enter a pictorial field. Long before a line is expressive it works in specifically plastic ways, taking direction, dividing up areas, delineating or circumscribing forms, and so on. A colour in painting is no longer the colour of something but a hue and a tone either contrasting with other hues and tones or related in shades and gradations. And, very importantly, forms do not act as substitutes for bodies in physical space but are spatial agents in the picture plane.

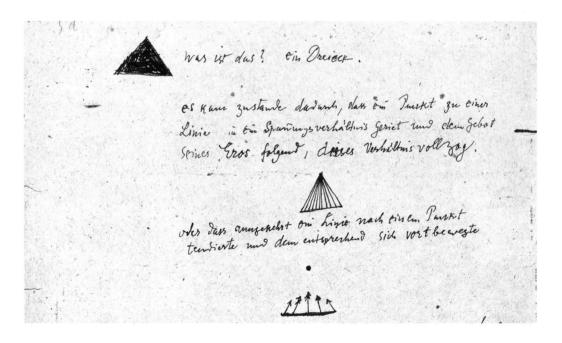

fig.1
Paul Klee
Dynamics of the
Triangle (detail)
Pedagogical Writings,
(PN6 M5/55), undated
Indian ink on paper
30.2 x 23.4 cm
Paul-Klee-Stiftung,
Kunstmuseum Bern

The triangle came into being when a point entered into a relation of tension with a line and, following the command of its Eros, discharged this tension. The tension between point and line is characteristic of the triangle. (*The Thinking Eye*, 1961, p.113)

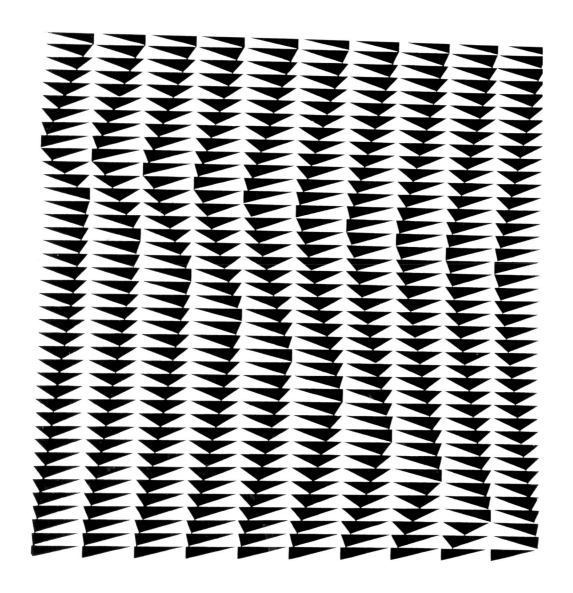

fig.2
Bridget Riley
Shift, 1963
emulsion on
hardboard
76.2 x 76.2 cm
Private Collection,
Germany
© Bridget Riley 2002

None of these characteristics can be foreseen. That they will occur cannot be doubted, but precisely how can only be discovered in the context of picture making. It was wonderful to see, during my visit to the Klee Foundation in Bern, clear and abundant evidence of the large part his analytical investigations had played in the preparation of his work. The 'discoveries' that he made were always highly objective, and this of necessity, as I found out in making my own preparatory studies. Klee is the great antidote to the confusion that persists around geometric abstraction and mathematics in painting. A geometric form in the picture plane does not work in terms of geometry. His most striking example is the triangle that in its mathematical definition is the direct connection between three points not on a straight line. But perceived as a pictorial figure the triangle is charged by the tension between line and point, between a base and a directional thrust (fig.1). That is to say in painting the triangle displays plastic properties that go beyond mere appearance. In the 1960s, when I started my black and white paintings, I was very much aware of this intrinsic potential in the elements and I used to refer to it as 'energy'.

There is the obvious difference that in my black and white work I turned these energies against formal stability as such (fig.2). Nevertheless, this was still, in its way, an extension of the rigorous stance that Klee took in his Bauhaus teaching against form as an end: 'Form as movement, as action, is a good thing, active form is good. Form as rest, as end, is bad. Passive, finished form is bad. Formation is good. Form is bad; form is the end, death. Formation is movement, act. Formation is life' (TE, p. 169)*. I still hold to this beautiful litany.

However, the plastic energy of form in the picture plane – which I called dynamism – constitutes only one of the many active relationships that eventually make up a painting. Among the 'pure pictorial relations', Klee lists 'light to dark, colour to light and dark, colour to colour, long to short, broad to narrow, sharp to dull, left-right, above-below, behind-in front, circle to square to triangle' (TE, p. 72). When combined, these relationships produce the highly complex sensation that is somewhat bluntly called 'pictorial space'. This has been the most fought-over territory in latter day Modern painting. The very notion of pictorial space seems to imply an illusion on the flat surface. It strikes one as very nearly comic now when one thinks that this 'illusion' has been prosecuted with an almost moral fervour ever since the 1950s, that is to say for well over forty years, as though it were dishonest or something close to fraudulence.

Klee's 'practical considerations in regard to space' in *The Thinking Eye* expose the vain zealousness that so haunted this debate from the start: 'The spatial character of the plane is imaginary. Often it represents a conflict for the painter. He does not wish to treat the third dimension illusionistically. Today a flat effect is often sought in painting. But if different parts of the plane are given different values, it is hard to avoid a certain effect of depth' (TE, p. 49). This is the great strength of Klee: you cannot deny pictorial fact – that which is palpably experienced. Any element that enters the picture plane, be it a line, a spot of colour or a tonal shade, is liable to create the sensation of depth. This is so real to our perception that it does not have to be fabricated as an 'illusion'.

If one understands correctly the word visible, as 'that which can be seen', then it follows that the realm of our vision is not confined to what we actually see, but encompasses a wider potential. That is to say there is a range of possibilities, a horizon of aspects latent in any perception to which Klee refers when he defines the aim of his art as 'making visible': 'Art does not reproduce the visible but makes visible' (TE, p. 76). This is not meant as a revelation in the sense of rendering visible something that was previously unseen, but as the opening up of our vision to the greater and fuller span of the generative force of life. In painting the thing seen is, at best, a factor that gives rise to both the actual perception and to the sensation that places it within our experience.

Perhaps this may be one of the reasons why the great paintings of the past are still able to touch us so directly. To return briefly to Vermeer, he seems to be of quite a different order to his fellow artists in the Netherlands because his paintings are not exhausted by rendering an existing subject matter nor by catching a momentary appearance, they

* *The Thinking Eye* is cited after the translation of 1961 with the abbreviation TE followed by the page number.

'make visible' in Klee's sense. With every new encounter Vermeer's paintings seem to begin again, reconstituting their own reality once more and at the same time accommodating our various spontaneous responses.

But this generative force that maintains the great paintings of the past in the present is still veiled by historical costume, as it were, veiled by the particular form of pictorial representation employed. What happens if the aim of 'making visible' is pursued without any commonly recognizable imagery? This question has long concerned me and continues to preoccupy my thinking. As an abstract painter I do not believe in the self-referential object. Even if this could be manufactured — which I doubt — it would be a dead end. On the other hand, Abstract painting cannot stimulate merely subjective associations, there must be a deeper form of recognition.

Although only part of Klee's creative interest is focused on pure Abstraction, he nevertheless goes a long way towards clarifying this issue. Recently I was looking with Robert Kudielka, my co-curator for this exhibition, at Klee's drawing *Bird Drama*, 1920 (cat. 15, p. 58). He pointed out to me the dot on the belly of this big cow-like bird on the left saying, 'it's the key to the whole drawing!'. This was enough to release the magic of visibility contained in a work that had previously been opaque. I immediately saw the connection between this cross-eyed creature and the small crowd of long-necked birds leering at her; noticed the significance of the mound with sprouting shoots on the extreme left in contrast to the barren heaps below the gossiping birds. Gradually even the right hand side of the drawing became clearer: the flash-like black arrow and the small bird which appears gleefully to blurt out the whole story — and perhaps was responsible for this entire comedy in the first place, who knows?

However, it is not so much the discovery of a way of deciphering this drawing that matters. It is rather the form in which Klee articulates a rather complex group of sensations that is important — sensations that, by the way, are also about creation. He articulates these so fully and precisely that one wants to return to the drawing over and over again, just for the joy of seeing it become visible once more. Above all a visual work of art seems to be capable of providing the pleasure of participating in the process that generates the visible. Or, as Klee says: 'The picture has no particular purpose. It only has the purpose of making us happy. That is something very different from a relationship to external life, and so it must be organized differently. We want to see an achievement in our picture, a particular achievement. It should be something that preoccupies us, something we wish to see frequently and possess in the end. It is only then that we can know whether it makes us happy' (TE, p. 454).

PAUL KLEE: THE NATURE OF CREATION

ROBERT KUDIELKA

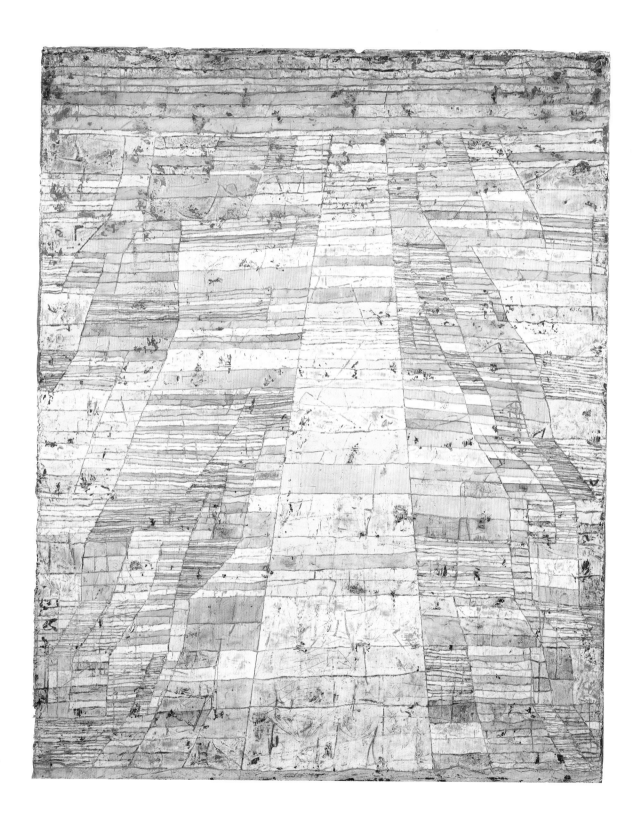

fig.3
Paul Klee
*Haupweg und
Nebenwege*, 1929
Main Way and
Byways
oil on canvas
83.7 x 67.5 cm
Stadt + Köln
Repro: Rheinisches
Bildarchiv Köln

PAUL KLEE: THE NATURE OF CREATION

ROBERT KUDIELKA

The position that Paul Klee occupies in twentieth-century art is exceptional. Although his work seems to be connected with most of the important movements and tendencies in Modern art, it is not rooted in any of them. There is no clear distinction between figuration and abstraction, let alone a development from one to the other. The strongly expressive, even expressionist, vein in his temperament did not prevent him making some of the most beautiful constructive paintings independently of the tenets of Constructivism. And much has been made, quite rightly, of the poetic qualities of his work that anticipated Surrealism by several years and prepared the ground for a whole genre of fantastic art. However, Klee's charm as a storyteller tends to conceal the fact that he produced what amounts to the largest body of analytical work realized by any great twentieth-century artist. Approximately 4000 pages of notes and studies are preserved in the archives of the Klee Foundation in Bern, Switzerland. The astonishing range of apparent contradictions in his work is crowned by a very special sense of humour – for a serious visual artist possibly the subtlest of all achievements.

It would seem almost possible, against the background of discourse in the last twenty years, to claim Paul Klee as a precursor of Post-Modernism. He never developed in any one direction alone, his creative practice was strictly non-exclusive, and crossing borders, the combining and transforming of different visual properties, was for him a customary way of proceeding. But this open and varied approach should not be interpreted as permissiveness or indifference. However great a favourite Klee may be with those collectors guided by personal taste, there is one quality that distinguishes his oeuvre from a simple agglomerate of different styles and options. Klee is, in the critical sense of the word, a 'fundamentalist'. This 'Pascal-Napoleon', as Picasso reportedly called him,[1] believed in a hidden source of creative power, and using all his ingenuity set about both tapping and maintaining its flow.

Artists have always sensed this quality in Klee's work. The enormous attraction Klee exerted right across the differing factions of the art world seems to have sprung from an immediate recognition that his work, far from indicating an end, constituted a beginning. Marcel Duchamp, who cannot be accused of venerating the prolific, admired the 'extreme fecundity' of Klee;[2] and the composer Pierre Boulez, as recently as 1989, paid tribute to this quality in *Le pays fertile: Paul Klee*, adroitly titling his observations on the artist after one of the artist's works.[3] Since the early 1920s there have been numerous painters who have owed their beginning as independent artists to the stimulus of Klee.[4] André Masson and Joan Miró were probably the first young painters who found in his work the dynamite they needed to liberate themselves from the prevailing orthodoxy – in their case, the dominance of Cubism. Furthermore, it should not be overlooked that Paul Klee was also one of the prime instigators of the greatest

re-orientation of Modern art in the mid-twentieth century. In the late 1930s and early '40s ambitious young American artists, dissatisfied both with the situation in the United States and with contemporary European art, found in Klee's work of the 1920s a starting point from which to embark on their quest for a new, genuinely American art. Writing about this period, Clement Greenberg recalled that 'almost everybody, whether conscious of it or not, was learning from Klee, who provided the best key to Cubism as a flexible, "all-purpose" canon of style'.[5]

But it is in the nature of Klee's influence that in the end it leaves very few apparent traces, if any. It could also be said that those who most diligently imitated the 'look' of his work were those who most profoundly misunderstood him and consequently fell into oblivion. To cling to the results of Klee's creative enquiry is to miss out on the real gift he has to offer. His unique capacity to set other artists free to make their own way was again recognized by Greenberg: 'His influence has been viable precisely because it could not occupy for its exclusive use all of the new territory it opened up.'[6] Klee himself did not really want to exploit fully the potential of his findings. On the contrary, with every step forward he tried to retain a vital connection with the point of departure, describing his position as an artist as 'closer to the heart of creation than usual, and still not close enough'.[7]

The urgent need to find a viable basis for artistic creation was a dominant feature of the first decade of the twentieth century. The generation that emerged around 1900 was no longer faced only with the authority of academic art, but also had to come to terms with the drawing to a close of the first great period of Modern painting, which took place in France. It was the era of the great 'memorial' exhibitions, as they were called at the time, which showed both the heroic achievement of the nineteenth-century masters and the impossibility of simply continuing in their way of working. Like many of his contemporaries, Klee was completely won over by the exhibitions of Van Gogh (1908) and Cézanne (1909) that he saw in Munich. But at the same time these artists seemed to offer no immediate direction for the future. The painters who formed the legendary 'chain' from Pissarro to Van Gogh and Gauguin did not provide the practical basis of a tradition, a reliable subject matter or working method, because their common understanding lay simply and solely in an elementary condition of working. Painting *sur le motif* allowed for many different individual responses, conceptions and forms of execution. 'Be an impressionist to the end and do not fear anything', Gauguin proclaimed enthusiastically,[8] and although Pissarro disliked what his former pupil made out of Impressionism, this maxim effectively unified the first fifty years of Modern art. Around 1900, however, this lease of life apparently ran out. It must have seemed as though the great protagonists had strengthened and rejuvenated art only to expose with fearful clarity the fundamental crisis at the root of the modern predicament: there is no objective basis, no traditional licence nor any social necessity for the making and continuation of art.

Such was the situation in which Klee, Matisse, Picasso and many others found themselves. They were the first group of Modern artists who could no longer fuel their imagination by simply rebelling against existing conventions. The need to find a

beginning was far more pressing and essential. It took Matisse and Picasso approximately eight years of continuous trial and exploration before either arrived at his particular point of departure, and it took Klee even longer. Perhaps due to his provincial background and a more introspective temperament, he struggled for twelve arduous years before he felt assured of his vocation. On 16 April 1914 he was ready to conclude his diary entry with the statement: 'I am a painter' (D 926 o)*.

This moment of recognition is inseparably connected with his journey to Tunisia and the origin of the 'square' paintings. But Klee's beginning differs significantly from that of his peers. Whereas both Matisse, in 1904, and Picasso, in 1906, began to push their work forward in a decisive manner, Klee's development was unique in the sense that, instead of concentrating on the line of inquiry initiated by his Tunisian experiences, he began opening up different lines until he had acquired such a broad spectrum that he could advance in several directions at once, working across a wide field of possibilities. His famous painting *Main Way and Byways*, 1929 (fig. 3) can be seen as a testament to this approach. In this work, the many vertical tracks leading to a horizon both close and distant, are simultaneously interlinked and bound by multiple horizontal progressions, which support the forward movement. The sophisticated self-awareness allowing for this mode of working seems to have germinated at around the same time as the triumphant eureka 'I am a painter'. The convergence of both these realizations justifies singling out the year 1914 as the critical starting point of Klee's career as an independent artist.

* The diaries are quoted after the translation of 1965, *The Diaries of Paul Klee, 1898–1918*, with the abbreviation D followed by the number and sometimes a letter from the artist's own register of entries. All quotations have been checked with the German original and occasionally adjusted.

1

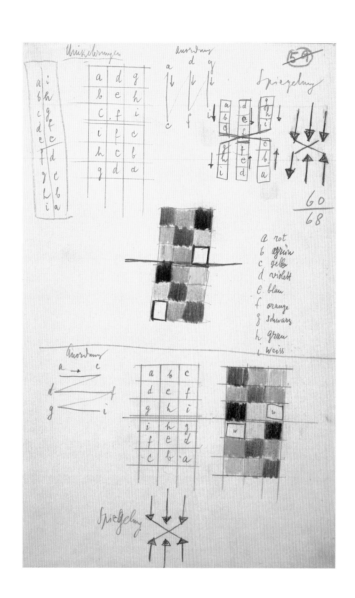

fig.4
Paul Klee
Reversal, Mirroring
Devices
Pedagogical Writings
(PN30 M60/68),
undated
coloured pencil on
paper
33 x 21 cm
Paul-Klee Stiftung,
Kunstmuseum Bern
Photo: Peter Lauri,
Bern

'COLOUR AND I ARE ONE' – THE JOURNEY TO TUNISIA AND THE ORIGIN OF THE SQUARE PAINTINGS

Apart from the work itself, Klee's diaries are our main source for understanding this formative period. However, in order to use this document properly, one has to remember that it has been severely edited by the author himself.[9] Klee began the journal one year before he started to study art in Munich and, except for the first few pages, which summarize some of his childhood memories, it seems to have served initially as a sort of notebook for his letter writing. But in 1904 he decided to edit these notes for a new purpose. He wrote to Lily Stumpf, who was to become his wife two years later, that in the main this re-working consisted of 'eliminating tastelessness and superfluous nonsense, and in criticizing each passage from the point of what had been accomplished'. And he added: 'I proceeded with the greatest irony, honesty and conscientiousness, not because I feared that somebody else would find things out, but with the intention of one day using this material for an autobiography.'[10] In this, Klee seems to have been prompted by the nineteenth-century Austrian poet, Franz Grillparzer, whose journal he read at the time with great fascination: 'An autobiographer could use this kind of self-analysis as a model' (D 553). From 1904 on, Klee conducted a process of critical self-examination in his notes and so it is not surprising that, between 1913 and 1921, he re-wrote all the years up to 1915, again 'from the point of what had been accomplished'. However, the most significant aspect of this editing is that he barely touched the last years, 1916 to 1918, when the diaries end. This suggests that in 1915 the self-analysis was complete, and painting became the primary focus.

Such complex re-writing would create an almost impenetrable barrier if one had to follow the intricacies of Klee's personal development. However, the real relevance of his diary is neither biographical nor historical, but is to be found in his work. In this regard the journals are an authentic document. The very fact that they were edited is an aspect of the task that Klee recognized as being particular to the modern artist. He realized that, academic training and preparation aside, it was up to him to become an artist. When in 1911 he began to record, classify and number his creative output in a work catalogue at the end of every year, he did this with the same intention of surveying and taking stock of his accomplishment. This attitude can be traced back to 1902 when he set himself the task 'to build modestly, like a self-taught man, without looking left or right' (D 430).

The diaries indicate that he advanced on two, initially divergent, levels. One concerned his desire to become a painter. During his studies with Franz von Stuck at the Munich Academy he realized that colour was his weakness. 'In the realm of colour I found it hard to progress', he noted around 1900 (D 122). Klee's gift lay initially in the graphic field. He had the eye and the facility of a caricaturist, rather like the young Monet, and he conquered colour similarly through the acuity of almost ruthless powers of observation. The narrative of the diary places clear emphasis on the most important steps in this development. Klee approached colour first through a prolonged and intense

exploration of tonality, and this is the 'modest way' that he was later to recommend to his students at the Bauhaus. It is not before 1907 that we find in his diary the sign of accomplishment that literally anticipates the happy moment of 1914: 'Tonality possesses me' (D 793).[11] But he continued to labour on the distinction between colour and tone, until we are told about more progress the following year: 'Learned how to differentiate tonality (with or without colour) from the colouristic. Got it!' (D 811). It was to take another six years before, on that April day in Kairouan, the journey seemed at an end: 'Colour possesses me. I do not have to pursue it, it will possess me always, I know it. That is the meaning of the happy hour: colour and I are one. I am a painter' (D 926 o).

This slow pace is perhaps not so surprising when one realizes that apart from teaching himself to be a painter, Klee had to overcome a second obstacle, the isolation of 'not looking left or right' that initially seemed necessary to him in the pursuit of his aim. Again the diaries show us what a long way lay ahead. It was already a courageous decision to leave his native Switzerland and study art in Munich. He completed his studies with the old academic custom of a tour of Italy (October 1901 to May 1902). Together with an artist friend he made a thorough study of Renaissance art and classical antiquity, duly distracted by the inevitable romance with Italy itself. His first real encounter with Modern art seems to have been through the paintings and, in particular, the etchings of Goya upon which he comments in 1904: 'It was more necessity than impulse, more a willingness to lay myself open to these things that were signs of the new times. For I may have been too much out of touch, after all' (D 578). This special interest in Goya grew in the following year when he spent a fortnight in Paris. There he browsed through the great collections apparently without – in 1905! – a single glance at the contemporary art scene. This reluctance to engage in the present seems to have continued right up until 1910 when the first notable artist of his own generation, the draughtsman Alfred Kubin, made contact with him. Thereafter the situation changed rapidly. In 1911, he met August Macke through Louis Moilliet, a painter and an old friend from his childhood, who also introduced him to Wassily Kandinsky, with whom Klee had studied in von Stuck's class, and who had, for a while, been living almost next door in Munich's Ainmillerstrasse.[12] Through the older artist, who had just finished writing *Concerning the Spiritual in Art* (published in 1912), he gained access to the Blue Rider group and, within a year, Klee was part of the contemporary Munich art scene. In 1912 he set out for his second visit to Paris, equipped with a letter of introduction to Robert Delaunay from Kandinsky. Apart from visiting Delaunay in his studio, he saw the work of Rousseau, Picasso, Braque, Matisse, Derain, De Vlaminck and others, finally catching up with the Modern art of his time.

Without this impetus the success of the Tunisian sojourn would have been barely conceivable. Together with Louis Moilliet and August Macke, whom he had persuaded to join him on the trip, Klee embarked in April 1914 on a journey that culminated in a fortnight spent around Tunis, St Germain, Hammamet, Sidi-Bou-Said and Kairouan. The watercolours Klee and Macke painted there have lent a legendary aura to these places and names. However, the sites themselves are not nearly as 'colourful' as the little works they painted might lead one to believe. In fact, the landscape as such seems rather dull: 'green-yellow-terracotta', as Klee noted on his first day out (D 926 f). It needed

the alertness of painters sensitive to the pictorial hazards of colour perception to see that the subtleties provided the clue. Commenting on 'the extremely subtle definition of the colours', Klee observed, 'nothing painfully bright as at home' (ibid.). The de-materializing power of the light created an atmospheric purity in which colours appeared close in tonal pitch, unclogged by substance – as long as one avoided midday, as Klee soon realized. It was the 'gently diffused light' of the dusks and dawns, 'at once mild and clear' (D 926 o), which added the pinks and rosy oranges to the yellows, greens and terracottas of his palette. Together with the whites of the houses and the blues of the sky these hues made up the colour palette of his Tunisian works.

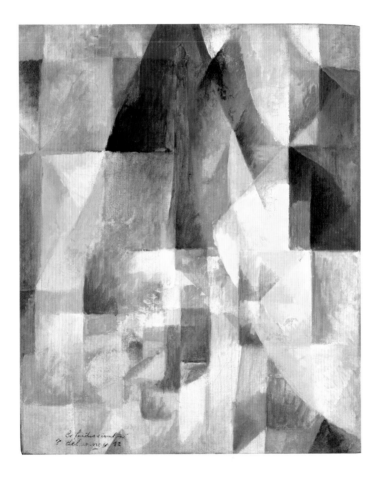

fig. 5
Robert Delaunay
Les fenêtres simultanées (2ᵉ motif, 1ʳᵉ partie), 1912
Simultaneous Windows (2ⁿᵈ Motif, 1ˢᵗ Part)
oil on canvas
55.2 x 46.3 cm
Solomon R. Guggenheim Museum, New York
Gift, Solomon R. Guggenheim, 1941
(41.464A)
© L&M SERVICES B.V. Amsterdam 20011112
Photograph by David Heald © The Solomon R. Guggenheim Foundation, New York

The freedom to organize this totality of colours owes as much to Delaunay's concept of the 'simultaneity' of colours in light (fig. 5) as it does to the North African sun. But right from the beginning there seems to have been a very personal streak in Klee's attitude to colour. While Delaunay concentrated on the prismatic spectrum and Macke tended to accentuate the blue and white contrast in his Tunisian works, Klee's range of strong hues seems to be carried by a warm undercurrent of ochre. *Watercolour*, 1914 (cat. 6), in particular, shows this subtle blending of blues, greens, yellows and reds with a pervasive sand colour that he was later to develop into a sophisticated interaction of light and earth colours, for example in *Static-Dynamic Gradation*, 1923 (cat. 35). And yet, it can be misleading to make too much of the beauty of the Tunisian palette for Klee's

breakthrough as a painter did not lie in the perception of colour as such, but rather in finding a way of responding to it pictorially.

Later Klee told his students at the Bauhaus that: 'To paint well is simply this: to put the right colour in the right place'.[13] We do not know whether they fully appreciated how hard-won an insight this was. Earlier, and with greater clarity than any other Modern artist, Klee identified the false beginning that bedevils artists when they can no longer complete a certain pre-determined task, working primarily as artificers, yet for a long time he was unable to respond to this insight. He analysed this dilemma in 1903 in a letter, to Lily, which may be regarded as a seminal document of Modern art:

'Assuming wrongly that I had to start from a poetic (lyrical, philosophical, literary) idea often led me into choosing a "subject" in advance and to executing it. And what happened? Either I was not at all as disposed to the figurative invention as I had imagined, being truly poetically stimulated – or I was disposed and invented something figurative, which could not be reconciled in any way with the "poetic idea". I found myself in an apparently awkward situation in that I had to change the subject in relation to the figurative invention, against which my artistic conscience rebelled. It would have remained silent had it not relied on that insufficient and false basis of a wrong assumption. For visual art never begins with a poetic mood or idea but with building one or several figures, with harmonizing a few colours and tones or with calculating spatial relationships etc. And whether an idea then, belonging to that other extraneous area, joins in or not, is completely irrelevant: It *may* do, but it doesn't *have* to.'[14]

In the Tunisian watercolours Klee fully achieved this radical beginning for the first time. It seems as though the intensity of the experience – 'Colour and I are one' – helped him to overcome the distraction of subject matter and to commence with 'spatial calculation': mapping out the areas of colour by squaring up the pictorial field. Of the approximately thirty works on paper completed either on the spot or soon afterwards, the majority are characterized by this procedure, and in varying degrees they bear out the predictions he had made twelve years earlier. Some of them link up with 'extraneous' figurative motifs, others remain abstract.[15]

In *Abstraction of a Motif from Hammamet*, 1914 (cat. 4) the regular dispersal of green and brown dots is sufficient to induce the sensation of sparse vegetation. Whereas *Red and White Domes*, 1914 (cat. 5) evokes the view of an Arab town with mosques simply through the insertion of semi-circles in the square pattern. This 'synthesis of urban and pictorial architecture' (D 926 f) seems to have been suggested originally by the motif itself. But in the 1920s Klee developed this association freely, as for instance in *Picture of a City (Red-Green Accents)*, 1921 (cat. 30), where the squares are subdivided and multiplied, either orthogonally or diagonally, to create a sparkling rhythm of city life.

In a comparable way the purely abstract structure of *Watercolour*, 1914 (cat. 6) was developed and built on in the 1920s. Within pure abstraction it is the analogy with musical abstraction that Klee, himself an accomplished musician, exploited with sophisticated directness. The colour sequences of *Static-Dynamic Gradation*, 1923 (cat. 35) are organ-

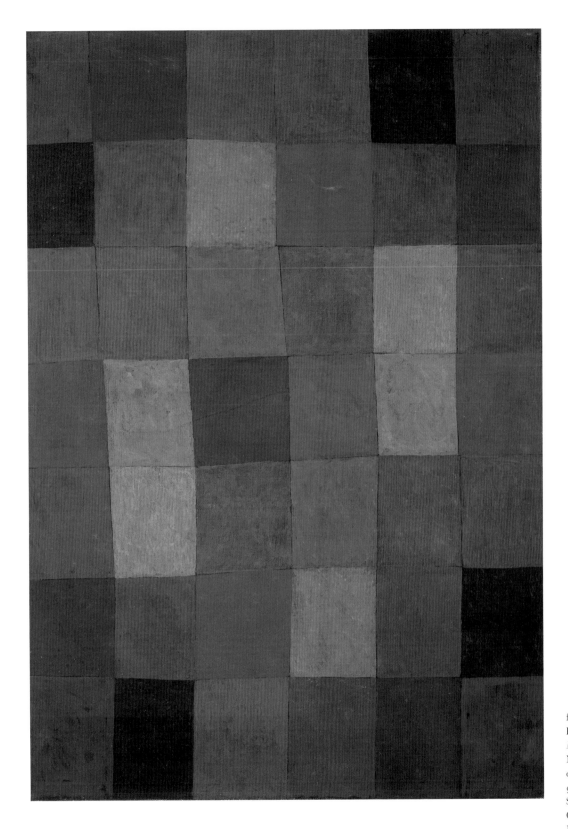

fig. 6
Paul Klee
Neue Harmonie, 1936
New Harmony
oil on canvas
93.6 x 66.3 cm
Solomon R.
Guggenheim
Museum, New York
(71.1960)
Photograph by David
Heald © The Solomon
R. Guggenheim
Foundation, New York

33

ized according to a diagonal reversal that relates to the so-called 'crab' device in music (fig. 4). With the exception of the central area, the structure is strictly mirrored along the central horizontal axis. In *Ancient Harmony*, 1925 (cat. 48) this regularity is almost completely diffused, only the tonal sequence of the two main horizontal progressions holding the golden chord in the centre appears to be reversed. But as late as 1936, the year of a severe creative crisis, Klee fell back on the classic solution and transformed it into *New Harmony*, 1936 (fig. 6), one of his most masterly abstract paintings. The 'Kairouan-style', as he called it, had become a backbone of his work.[16]

Squaring the picture plane was of course only one way of beginning. It is interesting that his first diary entry after the return from Tunisia focused on precisely this problem. 'In my work every time a type grows beyond the stage of its genesis, and I have about reached the goal, the intensity gets lost very quickly and I have to look for new ways' (D 928). Klee saw that his first beginning was too slight a basis to sustain his work, and he employed his recently acquired pictorial experience in a return to drawing: 'Graphic work as the expressive movement of the hand holding the recording pencil – which is essentially how I practise it – is so fundamentally different from dealing with tone and colour that one can use this technique quite well in the dark, even in the blackest night' (ibid.). The next few years were spent bringing some light into that darkness.

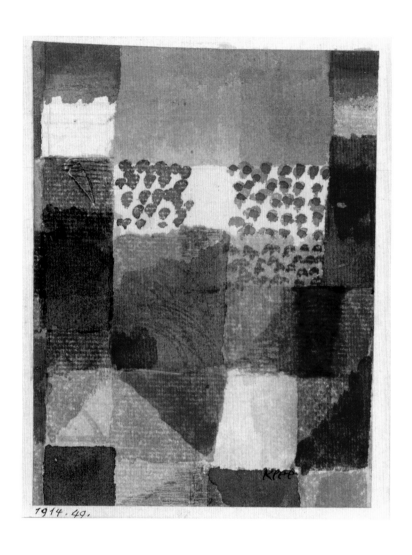

4. *Abstraction eines Motives aus Hammamet*, 1914 / Abstraction of a Motif from Hammamet

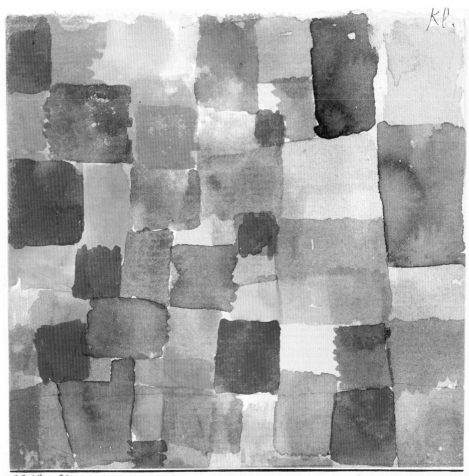

1914 94

6. *Aquarell*, 1914 / Watercolour

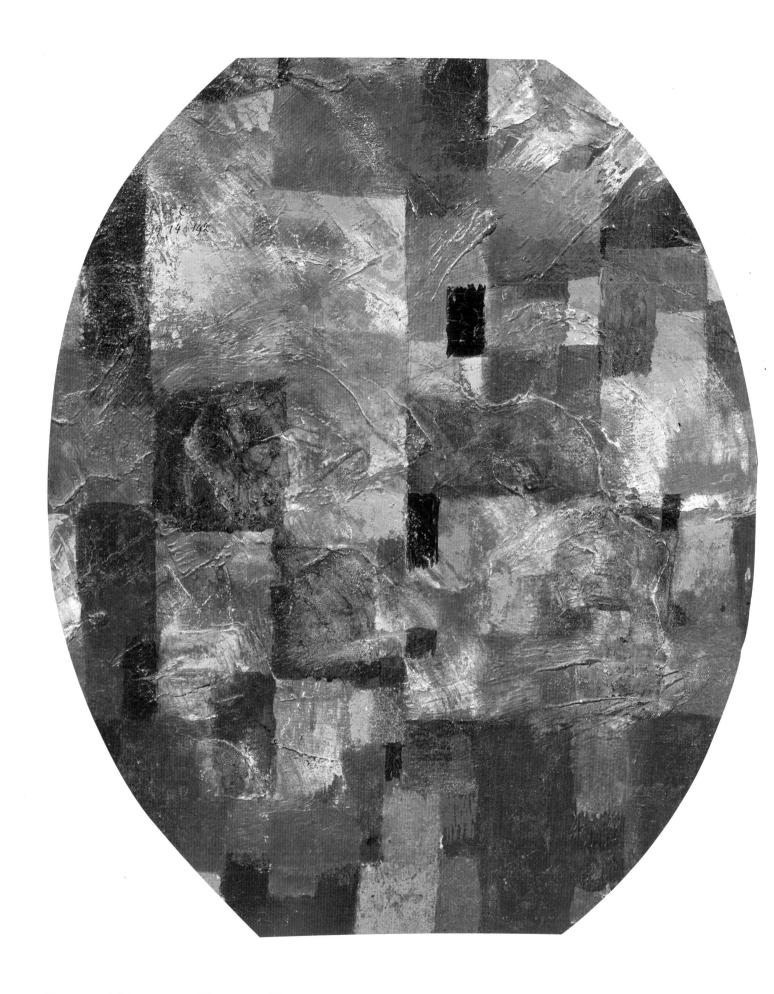

7. *Hommage à Picasso*, 1914 / Homage to Picasso

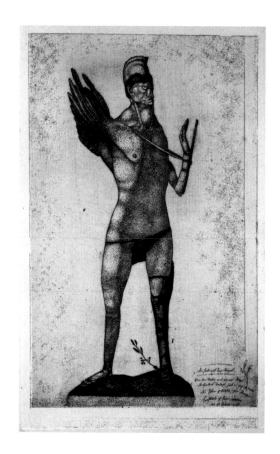

fig.7
Paul Klee
Der Held mit dem
Flügel, 1905
Winged Hero
etching on zinc
25.7 x 16 cm
Paul-Klee-Stiftung,
Kunstmuseum Bern

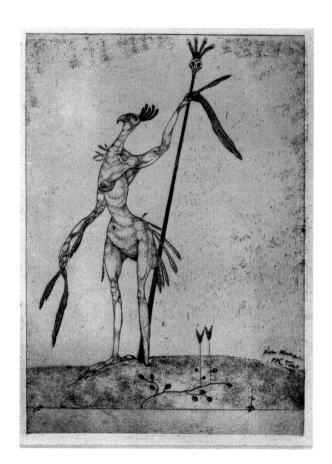

fig.8
Paul Klee
Greiser Phönix, 1905
Aged Phoenix
etching on zinc
27.1 x 19.8 cm
Paul-Klee-Stiftung,
Kunstmuseum Bern

'TURNING INTO THE CRYSTALLINE TYPE' – THE CRISIS OF

1914–15 AND THE FORMATION OF THE ARTISTIC PERSONALITY

Before the journey to Tunisia Klee's work had been mainly graphic with a pronounced satirical streak. This seems to be at odds with the poetic imagination that one associates with his mature work. Nevertheless these early attempts, culminating in a series of etchings titled *Inventions*, 1903 and in the illustrations to Voltaire's *Candide*, 1911, cannot simply be ignored as juvenile aberrations. Precisely because they show a very contrary spirit they are essential to an understanding of the shaping of Klee's artistic personality. Klee was initially drawn to satire by a feeling of utter personal and historical insufficiency in the face of the great heritage of western art. In February 1902 he wrote from Rome to his father, Hans Klee: 'Since I entered Rome I am spiritually mostly in a satirical mood.'[17] The art of the Renaissance and the monuments of antiquity had impressed him to such a degree that he felt virtually paralysed. 'The thought of having to live in an epigonic age is almost unbearable', he noted in his diary and projected for himself the following perspective: 'There are three things: a Graeco-Roman antiquity (physis), with an objective attitude, worldly orientation, and an architectonic centre of gravity; and a Christianity (psyche) with a subjective attitude, other-worldly orientation, and a musical centre of gravity. The third is the state of the modest, ignorant, self-taught man, a tiny ego' (D 430). The distinction between an outwardly orientated antique art and an inwardly centred Christian art is a cliché of German Humanism which was developed in the great period of Idealism between Schiller and Hegel at the beginning of the nineteenth century, and it is worth noting that it has survived in the reception of Klee's work in the guise of the opposition between the Northern European and the Mediterranean spirit.[18] By adding his own third position, however, Klee himself dispensed with this formula, as a high-flown generalization, irrelevant to the real problems of the Modern artist.

Klee's early satirical work is aimed at the hollowness of adopted cultural values, and in disguising them it reveals an astonishingly precocious acuity. *Winged Hero*, 1905 (fig. 7) from the series *Inventions*, for instance, shows a tall figure standing grimly with one wooden leg rooted to the ground, as a shoot sprouting from the heel indicates, while waving a battered, winged arm. The image cannot be better described than in the artist's own words: 'The man, born with only one wing, in contrast with divine creatures, makes incessant efforts to fly. In doing so, he breaks his arms and legs, but persists under the banner of his Idea. The contrast between his solemn stature-like attitude and his already ruined state needed especially to be captured, as an emblem of the tragicomic' (D 585). In a similar way the etching of the *Aged Phoenix*, 1905 (fig. 8) from the same series exposes the worn myth of eternal renewal. The mythical bird, with the stump of one leg resting on the ground, has lost almost all its feathers and appears to be very plainly human. The artist explained this 'allegory of insufficiency' in a letter to Lily: 'One has to imagine, for instance, that there has just been a revolution, insufficiency was burnt, and now it rises, rejuvenated, from its own ashes.'[19]

The sarcastic power of these images is due, to a considerable degree, to their being intensely felt as ciphers of the artist's own situation. Klee confessed to his future wife that he sometimes 'indulged in the utmost, self-mockery, which is the highest demoralization.'[20] But on the objective side these satires also express Klee's political views of the time and the society in which he lived. The later notion of Klee as a dreamer has almost completely obscured the rebellious stance with which he sympathized with the radical Left as a young man. He was deeply upset by the separation of work and luxury in bourgeois society, and all the excitement over the great works of art he saw on his first visit to Paris in 1905 seems to have been forgotten in an early morning visit to Les Halles. He reports: 'We saw prostitutes skipping with their men, just as in the Rococo period. And against the wall, sitting partly upright, rows of workers were sleeping, reminding one of the Revolution.'[21] The year 1905 in particular seems to mark an extreme point in Klee's critical distress about his social and political standing as an artist. Apart from completing the *Inventions* etchings, he transcribed long passages from a translation of Oscar Wilde's *Soul of Man under Socialism* (1891) in his letters to an eager and sympathetic Lily, hoping to somehow resolve his inner conflict.

By the middle of 1915 all these problems seem to have disappeared. Klee had transformed himself into 'the crystalline type', as he stated in his diary: 'against which a pathetic lava is ultimately powerless' (D 953). This does not mean that he had lost his critical attitude to contemporary society. Far from it. During the short revolutionary interlude of the communist 'Räterepublik' in Bavaria, in April 1919, Klee was immediately ready to join the Council of the Fine Artists of Munich. 'The Action Committee of Revolutionary Artists may dispose completely of my artistic capabilities', he wrote, carried away by revolutionary fervour.[22] And, throughout the 1920s, he continued to exhibit with the leftish November Gruppe in Berlin.[23] His new 'crystalline' stance was related solely to his work; it was the satirical sting of the artist that had been drawn, not his sharp social perception.

This change of attitude was certainly precipitated by the outbreak of the First World War. Klee was in Switzerland when Germany declared war on Russia, on 1 August 1914, and shortly afterwards wrote to Kandinsky: 'As far as I am concerned, I would, on the one hand, rather be there right now, for in spite of everything – these times have a certain grandeur. Though it does hurt that they appear reactionary from the standpoint of our further aspirations.'[24] These 'further aspirations' refer to the dream of an internationalist art opposing nationalism. But with the term 'a certain grandeur' Klee strikes a note quite prevalent at the time among German artists such as Beckmann, Dix, Marc and others who had distanced themselves from the decadence of contemporary life. Kandinsky indirectly corrected this notion in his reply by speaking of 'these terrible times';[25] and, when a few days later, August Macke, his Tunisian travel companion, was reported missing and then killed in action, Klee's naive enthusiasm for the war changed drastically. By the end of December he wrote to Kubin: 'It no longer stimulates me. I am entirely with myself, somewhere, lower than low, but very much alive.'[26] And some time around the middle of 1915 he entered in his diary the famous observation: 'I have long had this war inside me. This is why, inwardly, it means nothing to me' (D 952).

In order to understand this remark, it is essential to see it as the outcome of a long, partly tacit, partly verbal dispute with Franz Marc and the heritage of German Romanticism, which he so strongly represented. Knowing each other from the days of the Blue Rider, both artists had a shared contempt for a culturally corrupt society, and Marc in particular was a fervent believer in Kandinsky's 'new age of the spiritual'. Marc volunteered for service in the first week of the war, beginning a correspondence with Kandinsky that remains a remarkable document of the confusion of an absolutely pure mind. He felt in a trance-like state between 'dream' and 'action' during the first weeks of fighting in the Vosges and associated this feeling with Kandinsky's early abstract paintings 'which accompany me like formulas of such a state.'[27] To him this war, at least at the beginning, appeared as a 'wholesome though cruel transition to our goals', i.e. the coming age of the spirit: 'it won't throw back humanity, but *purify* Europe, "prepare" it'.[28] Klee, who had returned to Munich and kept in close contact with Marc's wife and friends, became increasingly alienated and started to clarify his own position in a direct response to that of Marc.

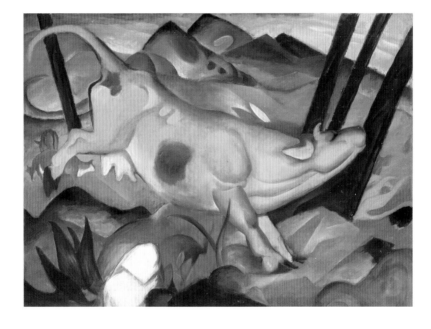

fig. 9
Franz Marc
Gelbe Kuh, 1911
Yellow Cow
oil on canvas
140.5 x 189.2 cm
Solomon R.
Guggenheim
Museum, New York
(49.1210)
Photograph by David
Heald © The Solomon
R. Guggenheim
Foundation, New York

With all its unmistakable and clear contradistinctions this dispute is nonetheless a tribute to their friendship and the predicament they shared: the Romantic desire to overcome egotism, as the source of human isolation and the cause of all evil in the world. In comparing their respective attitudes, however, Klee focused on Marc's love of creation and his readiness to sacrifice, which exaggerated subjectivity instead of overcoming it, and that to a dangerous degree. As an example he chose Marc's relationship to animals, the main subject of his paintings (fig. 9): 'I do not love animals and every sort of creature with an earthly warmth. I do not descend to them or raise them to myself. I tend rather to dissolve into the whole of creation, thus being on a

footing of brotherliness with my neighbour, with all things earthly ... My love is distant and religious' (D 1008).

This is a fundamental criticism of the subjective viewpoint underlying the Romantic desire to be one with the world. Klee sees that Marc's vision of animals as symbols of a life in harmony with nature is a human projection, although probably not as fatal a projection as his artistic idealization of war.[29] However innocently and naively, the Romantic spirit suffers from a peculiar kind of totalitarian humanism, an all-embracing enthusiasm that can be overbearing.

Klee's sceptical distance to this sentiment seems to have been aroused at an early stage by his discovery of Voltaire's *Candide*. In January 1906 he noted in his diary: 'I read a unique book, *Candide* by Voltaire. Three exclamation marks' (D 743). This parable of the limits of human power accompanied him for almost twenty years. Between 1911 and 1912 he completed a series of illustrations, eventually finding, in 1922, a publisher for this project. But, even more importantly, the last sentence of the book, Voltaire's summary and conclusion, can be regarded as a motto for Klee's mature work: 'Il faut cultiver le jardin'.

However, the 'cool Romanticism' (D 952) Klee pursued from 1915 on cannot be fully accounted for by this sceptical attitude alone. It is necessary to see that in resisting all-embracing sentiment he was embarking on a more radical quest. 'I am searching for a more remote, more original point of creation' (D 1008), he wrote in relation to Marc, distinguishing his claim for a 'footing of brotherliness'. The meaning of this becomes clear when one compares the dour emblems of the human tragicomedy, *Winged Hero* (fig. 7) and *Aged Phoenix* (fig. 8), with his later creations. It is not that as a mature artist Klee denies the human aspiration to soar on wings, or complains of the forces of gravity. On the contrary, flights of imagination and material bonds form the parameters of the tension within which his work moves. What has been foregone as the sole and central subject of creation is the human figure, and this shift of emphasis is accompanied by the transformation from acid satire to a very particular humour.

A clear example of this important shift is the difference between the etching *Woman and Beast* of 1904 (fig. 10) and the painting *Young Lady's Adventure*, 1922 (cat. 33). Both works show a female figure with a dog-like creature, but whereas the etching is a comic comment on sexual hypocrisy,[30] be it Victorian or Wilhelminian, the later image strikes a completely different note. Instead of a solitary configuration in an empty space, the young lady and her dog are surrounded by a magical forest of plants, birds and other creatures of all kinds. Bent gently forward she pursues her way through this forest, serenely unaware of the red eyes, arrows and other dangers around her.

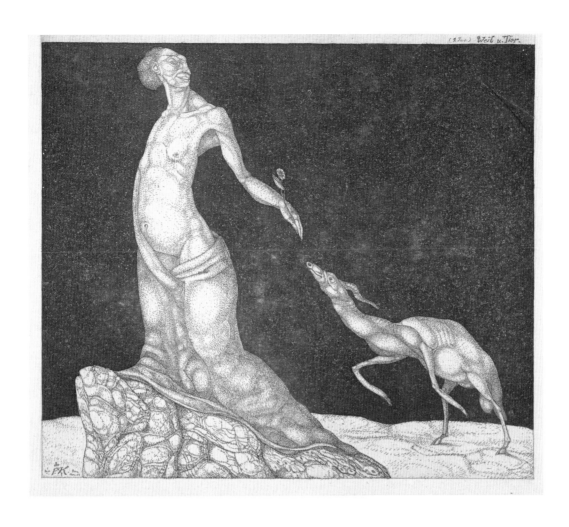

fig.10
Paul Klee
Weib u. Tier, 1904
Woman and Beast
(print before edition)
etching on zinc
19.7 x 22.5 cm
1904-13
Paul-Klee-Stiftung,
Kunstmuseum Bern
Photo: Peter Lauri,
Bern

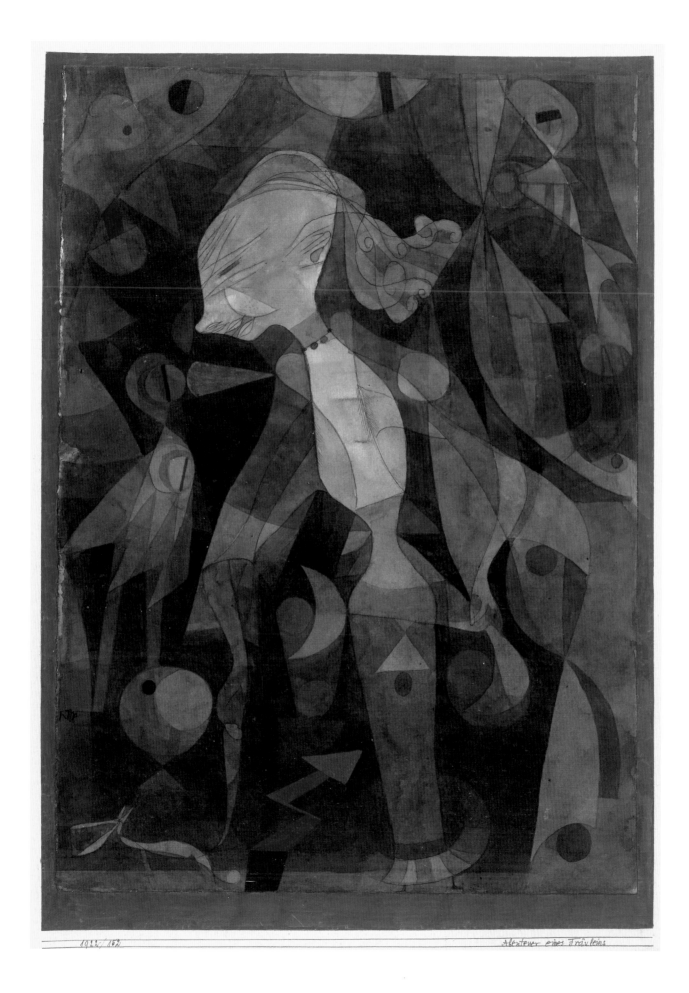

33. *Abenteuer eines Fräuleins,* 1922 / Young Lady's Adventure

3

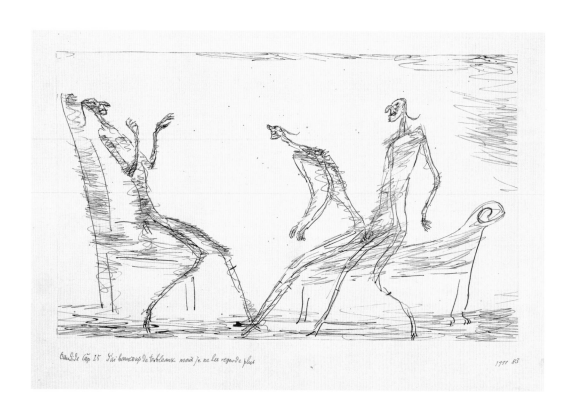

fig. 11
Paul Klee
*Candide Cap 25. J'ai
beaucoup de tableaux
mais je ne les regarde
plus*, 1911
I have plenty of
pictures, but I no
longer look at them
pen on paper mounted
on card
14.8 x 24.7 cm
Paul-Klee-Stiftung,
Kunstmuseum Bern
Photo: Peter Lauri,
Bern

'THE POINT SET IN MOTION' – THE NARRATIVE LINE

BETWEEN FANTASY AND CONSTRUCTION

Although the full extent of this change in attitude did not become apparent in Klee's work until after the war, the dissolution of the human figure was foreshadowed in the *Candide* illustrations (fig. 11) and the subsequent drawings. Related to the chapters of Voltaire's book these illustrations endeavour to reflect the sceptical humanism of the novel rather than to represent specific episodes. The characters are reduced to thin, elongated spectres made up of loose contours, which are frequently cross-hatched, and disembodied as they are, their poses, movements and gestures are set in a pictorially unqualified void. Many years later, in 1928, Klee referred, in a letter to Paul Éluard, to the 'struggle' that lay behind these works.[31]

Nevertheless this struggle seems to have been essential in engendering a further decisive step: suspending subjectivity in the creative process. The label of 'subjectivity', so often attached to Klee's art, shows a misunderstanding of both the nature of his work and the meaning of the term. The subjective imperative is in fact the very attitude that Klee excluded from his work. His drawings in particular reveal that far from being driven by the intention to characterize, to describe or even formalize something, Klee started out with nothing but the point of his pencil and the impulse to set it in motion. 'The original movement, the agent, is a point that sets itself in motion (genesis of form),' he wrote. 'A line comes into being. It goes out for a walk, so to speak, aimlessly for the sake of the walk' (TE, 105)*.

Klee began to concentrate on this way of drawing in 1919 after earlier attempts in a Cubist-type manner. He takes both his imagination and ours on a journey that opens up unforeseen landscapes, as he himself suggested in a famous passage from the so-called 'Creative Credo' (1920). But the trajectory of the line could also lead to constellations that were directly reflective of the artist's own intuitive hunches. In *They're Biting*, 1920 (cat. 10) small fish approach the lines of two anglers while larger ones lie waiting below, unimpressed. Or the hand of the artist, in sweeping gestures from left to right, could release the movements of *Veil Dance*, 1920 (cat. 11). But all these configurations would only be recognized en route and named at the end, instead of being intended and sought from the outset.

Such a way of working seems to be extraordinarily close to the Surrealist 'psychic automatism', as christened by André Breton in 1921. Indeed, claims could be made for Klee as one of the founding fathers of Surrealism. As early as 1919 Max Ernst discovered his work in Munich, and the news reached Paris in 1922, when Louis Aragon wrote from Berlin 'In Weimar there flowers a plant resembling the enchanter's nightshade'.[32] At around the same time Masson seems to have shown his studio neighbour, Joan Miró,

* Klee's notebooks are cited after the translation of Jürg Spiller (ed.) *The Thinking Eye*, 1961 and *The Nature of Nature*, 1973 with the abbreviations TE and NN followed by the page numbers. Some quotations have been adjusted in relation to the German text.

a book with reproductions of Klee's work. Thus it was hardly surprising that, when Klee had a solo exhibition in Paris in 1925, it was immediately followed by his inclusion in the first Surrealist show.[33] And yet, despite all the persuasion of his admirers in France – Aragon, Éluard and René Crevel in particular – Klee remained rather distant and remote albeit in a friendly way. In 1930 Alfred Barr Jr described the paradox of this relationship admirably: 'Klee was "claimed" by the Sur-réaliste group in Paris but found (as did Picasso, Braque, and de Chirico) that he was not especially interested. His work is, however, perhaps the finest realization of their ideals of an art which appears to be purely of the imagination, untrammelled by reason or the outer world of experience.'[34]

This closeness, and at the same time distance, helps to clarify Klee's position in several ways. First of all, he never referred to the 'unconscious', so dear to Breton's understanding of automatism as a 'dictation of the unconscious'.[35] For Klee it was the unintentional approach that was crucial to his drawing, and for this he orientated himself in the grammar of ancient Greek, with which he was familiar through his classical education. There is a middle voice between the active and passive in ancient Greek, which is used for all those actions that are neither actively directed nor passively endured, such as 'appearing', 'speaking', 'dancing' (cf. TE, pp. 103-20). Drawing as the movement of a point 'that sets itself in motion' can be seen as such a middle voice. There are many references to the analogy between drawing and speaking in Klee's work quite apart from the poetic fabrication of his titles. To his students at the Bauhaus, he said: 'At root word-making and form-building are the same thing' (TE, 17).

This different orientation allowed for the introduction of constructive elements in the linear narrative, which would have been considered sacrilegious in Surrealist doctrine. Proceeding in straight lines and sharp turns is as legitimate a way for Klee of 'setting the point in motion', as developing imaginary landscapes or fantastic figures. Only the resulting space is completely different, as *City in the Intermediate Realm*, 1921 (cat. 20) shows. When straight lines are interconnected by varying angles, spatial planes inevitably emerge, which in this drawing are deliberately not closed off or controlled by vanishing points. By suspending the ground plane and dispersing the focus an interpenetration of top and bottom, interior and exterior is created, an 'intermediary realm', which is Klee's very personal response to Cubist space. In pursuing this line of approach he could even employ straightforward perspectival devices, as in *Room Perspective Red/Green*, 1921 (cat. 21) or *Uncomposed in Space*, 1929 (cat. 68), only to dissolve their centripetal bias in an open, multidirectional continuum.

The most telling divergence, however, is also the subtlest. Like 'écriture automatique', Klee's narrative line tends to produce certain recurrent formal characteristics such as the organic shapes in *Distillation of Pears*, 1921 (cat. 19); the suggestive combination of objectively unrelated forms in *The Bud of the Smile*, 1921 (cat. 28); or the ambiguity between still life and heads in *Strange Flora Set on a Table*, 1921 (cat. 27). But there is a distinct difference in dealing with these undetermined, pre-objective images. Whereas Masson, for instance, in his early automatic drawings such as *La Naissance des Oiseaux*, 1925 (fig. 12), tries to preserve a free-floating allusiveness, Klee sets out to turn nascent

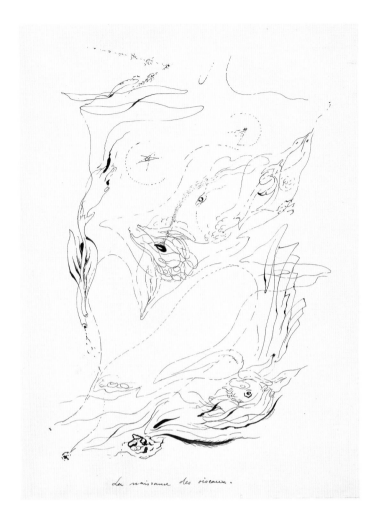

La naissance des oiseaux.

fig. 12
André Masson
*La Naissance des
Oiseaux, c.*1925
Birth of Birds
ink on paper
41.9 x 31.4 cm
The Museum of
Modern Art, New
York, Purchase
© DACS 2002
Photograph © 1997
The Museum of
Modern Art, New
York

formations into an explicit vocabulary. He analyses the sensation of an ambiguous growth expanding in several directions at once, finding for it a formal equivalent in the 'germinating patch' that informs *Vegetable-Physiognomic*, 1922 (cat. 34) and, in particular, *The Pathos of Fertility*, 1921 (cat. 26). In the latter work these plasmatic shapes are bundled into a kind of pot inside a human figure, which writhes with the tensions emanating from this inner ferment of potential.

In reflecting the powers of creativity, *The Pathos of Fertility* reveals a detachment that is in direct opposition to the claims of Surrealism. The two little fruits in the top left corner, so clearly despised by the writhing figure, are an amusing comment on any attempt to attach too great a value to Breton's famous pronouncement that 'beauty shall be convulsive or it shall not be'. Unleashing the fantastic was for Klee only one aspect of his creative work, and this is underlined by the fact that most of these imaginative explorations are, in their final form, soberly calculated artistic transformations. The subtle fusion of line and colour in *They're Biting, Veil Dance, City in the Intermediate Realm* and *The Pathos of Fertility* was arrived at by a very personal technique which the artist called 'oil-colour drawing'.

In early 1919, at the same time as tackling painting in oils, Klee was searching for a way of introducing colour into his drawings without having to paint up to the line, or to colour in forms. The slowly drying oil paints suggested a translation of the definitive line into the softer medium by a kind of two-stage copying process. Having copied an existing drawing on to tracing paper, Klee would cover a sheet of Japan paper with a thin film of black oil paint, and when it had dried sufficiently, but not completely, he would use this like a carbon in order to trace the line through on to a fresh sheet. The result was a less consistent, more granular line that could be worked over loosely with watercolour because the ridges of the oil paint, together with some faint traces of the hand's pressure, would hold their own. Many of the colour drawings of the 1920s were made in this way, and in familiarizing himself with the results of this technique, Klee finally managed to recreate them directly in oil as, for instance, in *Conjuring Trick*, 1927 (cat. 63).

Apart from combining drawing and watercolour, this transfer technique enabled Klee to go one step further and to merge two independent pictorial devices, the narrative line and the squaring of the colour field. The oil-colour drawing *Dance of the Moth*, 1923 (cat. 37) is based on a study of 1922, which shows a highly abstract 'creature' flying upwards. Both the steep ascent and the anatomy of this creature are expressed by four arrows pointing sharply downwards, while a fifth arrow seems to have struck its breast. By anchoring this formation in a grid of squares, which graduates from a dark blue border to two pools of light, Klee makes explicit the passage of the 'moth' as a movement toward light, whilst emphasizing the trapped sensation of a creature powerless to resist the lure of light.

This cross-breeding of different procedures was to become a standard method, prompting new levels of approach which in turn could be recombined. In this way the simile of the crystal refracting light, which Klee adopted initially to defy the 'lava of emotion', gave way to the more organic analogy of the tree as propounded in the lecture he gave at Jena in 1924. There, Klee described his role as an artist as that of a mediator or conduit: being rooted in the common ground of social life and nature, the artist performs the function of focusing and channelling creative energies, in the same way as does a tree trunk, so that they can unfold and become visible in the 'crown'. 'He neither serves nor commands, but acts only as a go-between. His position is humble. He himself is not the beauty of the crown, it has merely passed through him' (TE, p. 82). But this beauty in Klee's case is a very particular one, because it consists of a variety unmatched by any tree in nature.

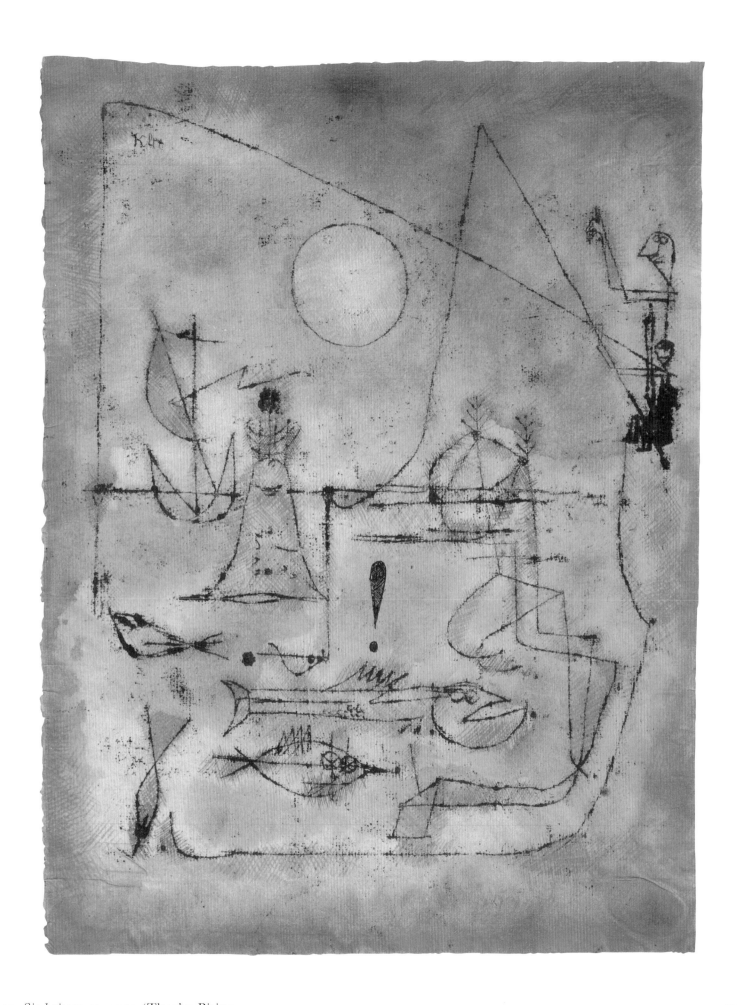

10. *Sie beissen an*, 1920 / They're Biting

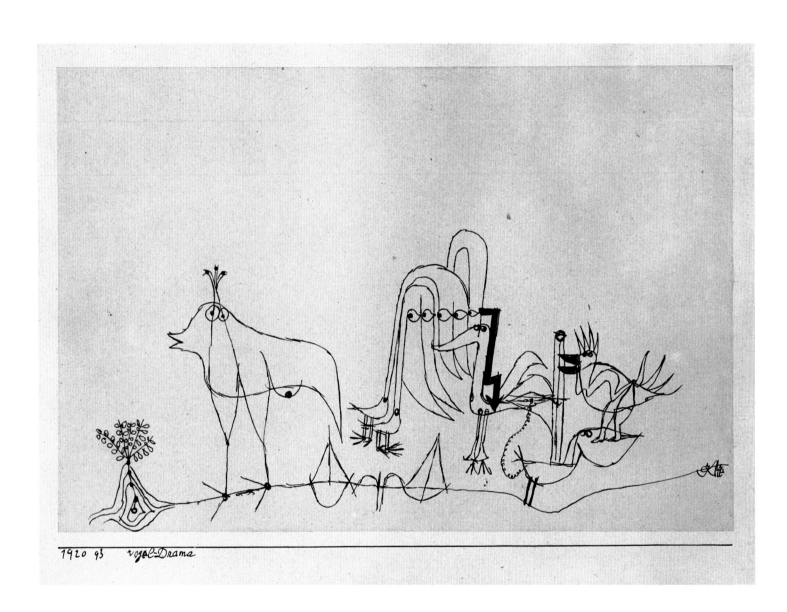

15. *Vogel-Drama*, 1920 / Bird Drama

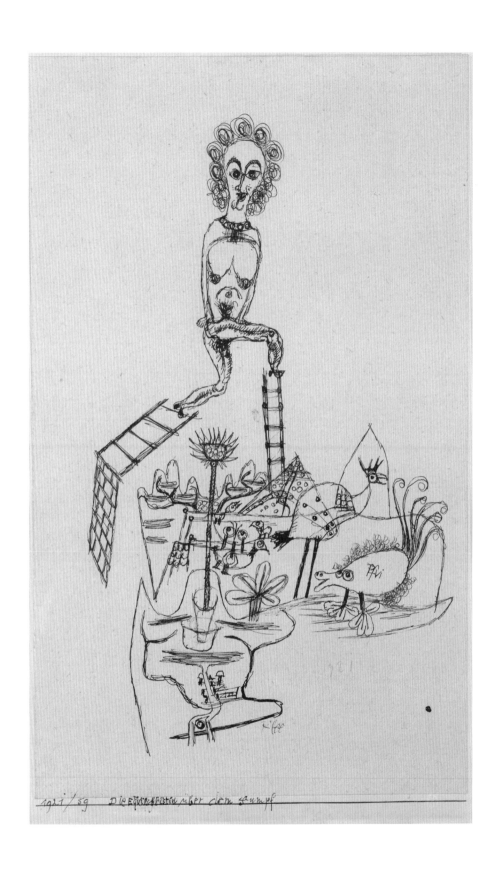

22. *Die Equilibristin über dem Sumpf*, 1921 / She-Equilibrist Over the Swamp

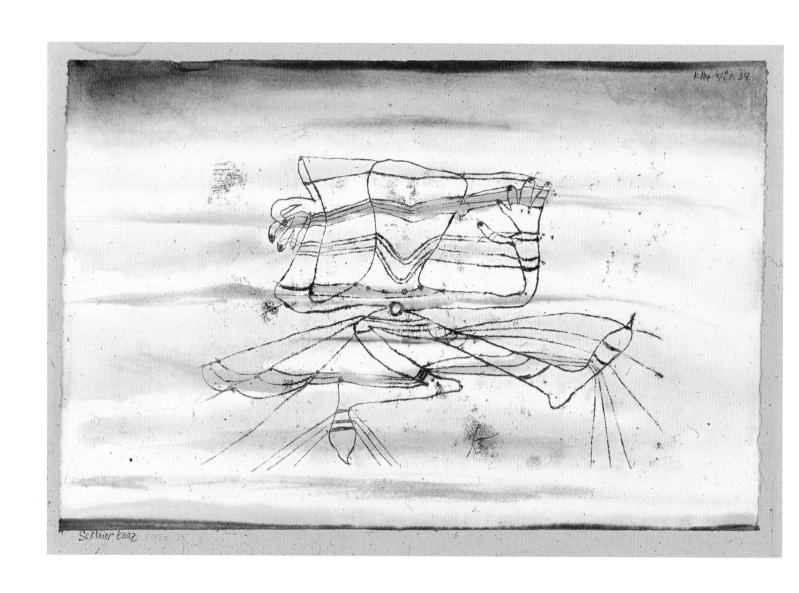

11. *Schleiertanz*, 1920 / Veil Dance

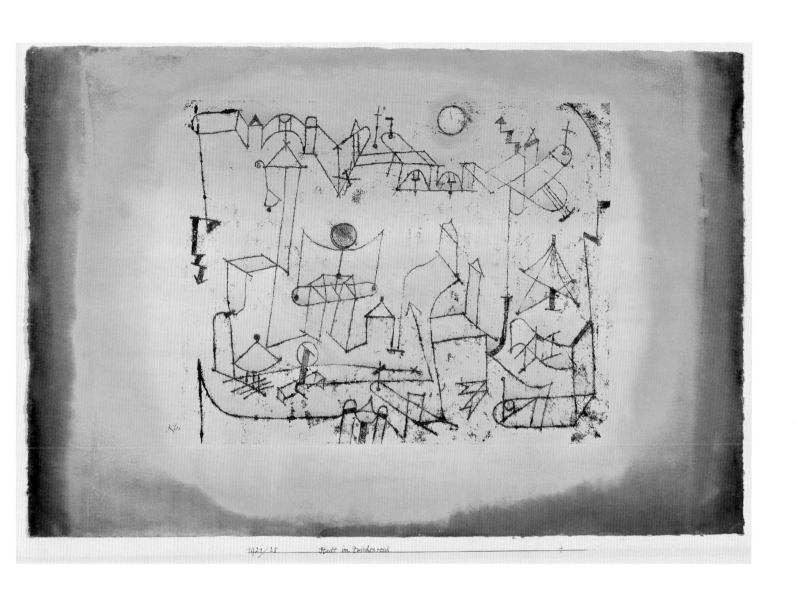

20. *Stadt im Zwischenreich*, 1921 / City in the Intermediate Realm

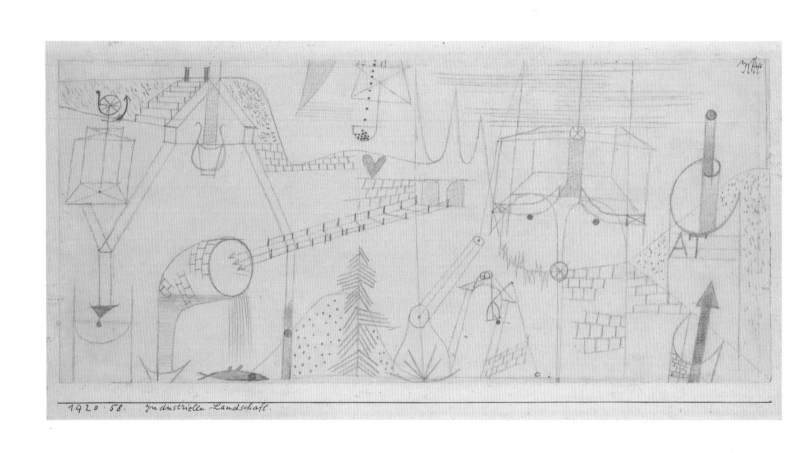

13. *Industrielle Landschaft*, 1920 / Industrial Landscape

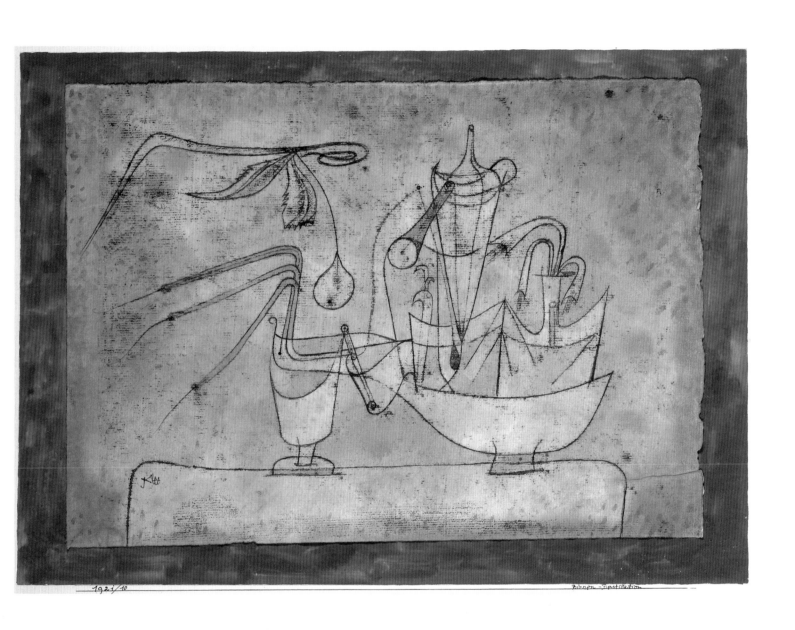

19. *Birnen-Destillation*, 1921 / Distillation of Pears

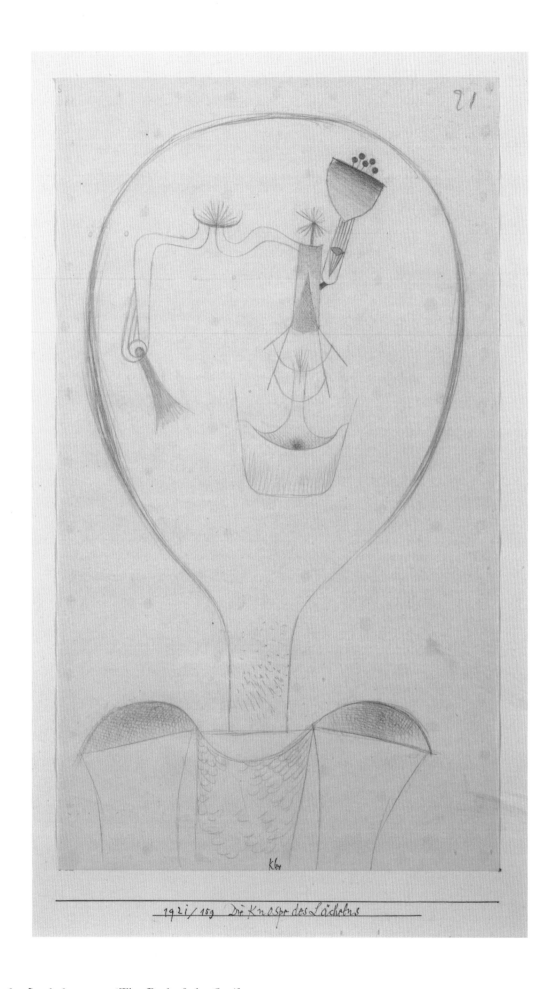

28. *Die Knospe des Lächelns*, 1921 / The Bud of the Smile

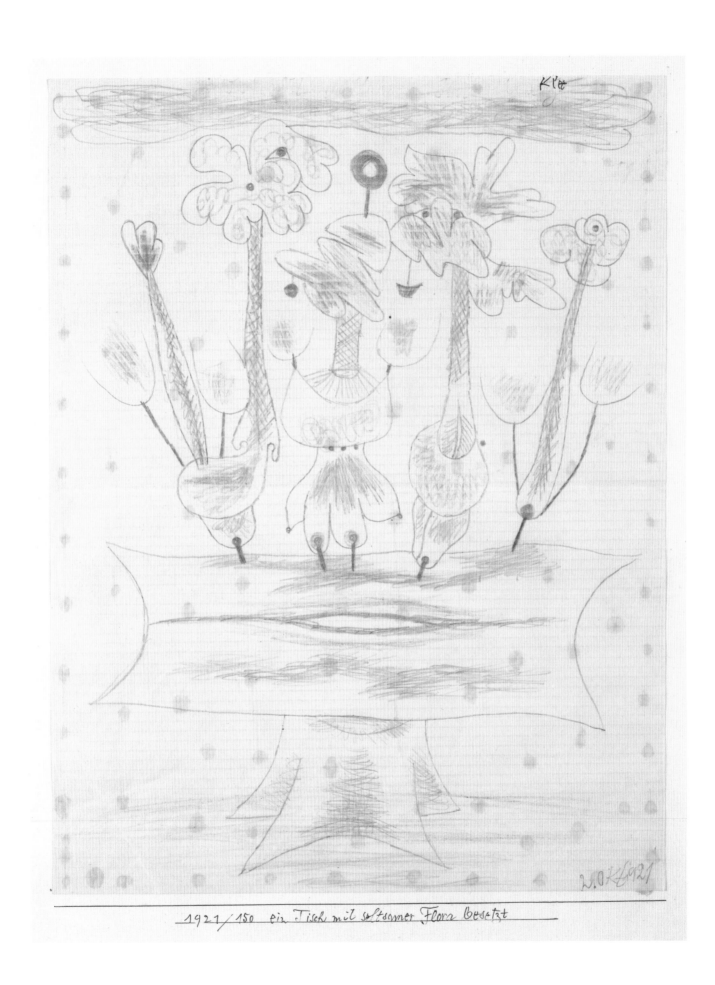

27. *Ein Tisch mit seltsamer Flora besetzt*, 1921 / Strange Flora Set on a Table 65

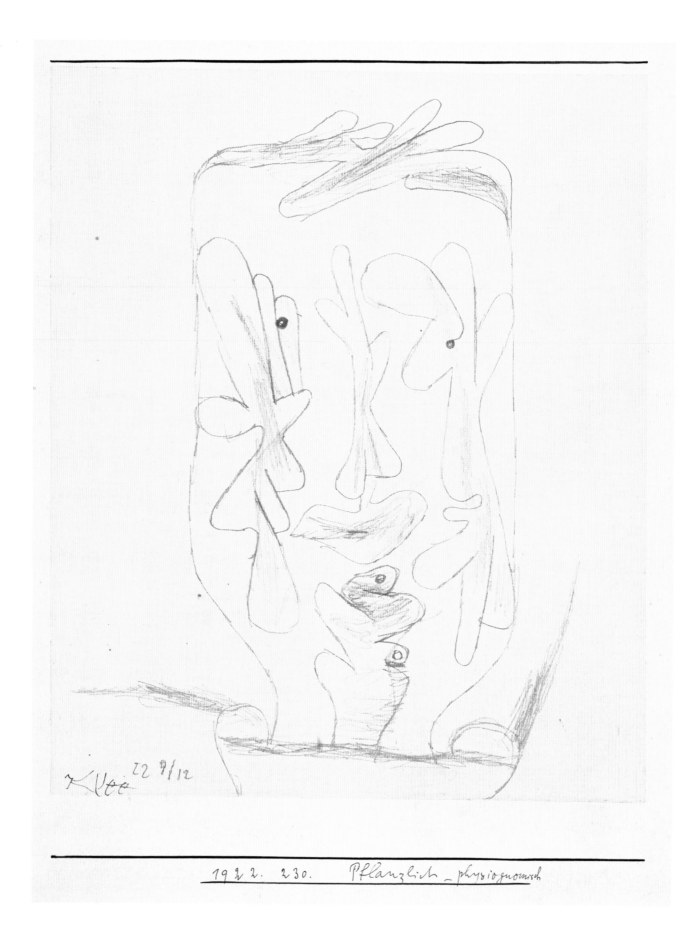

1922. 230. Pflanzlich_physiognomisch

34. *Pflanzlich-physiognomisch*, 1922 / Vegetable-Physiognomic

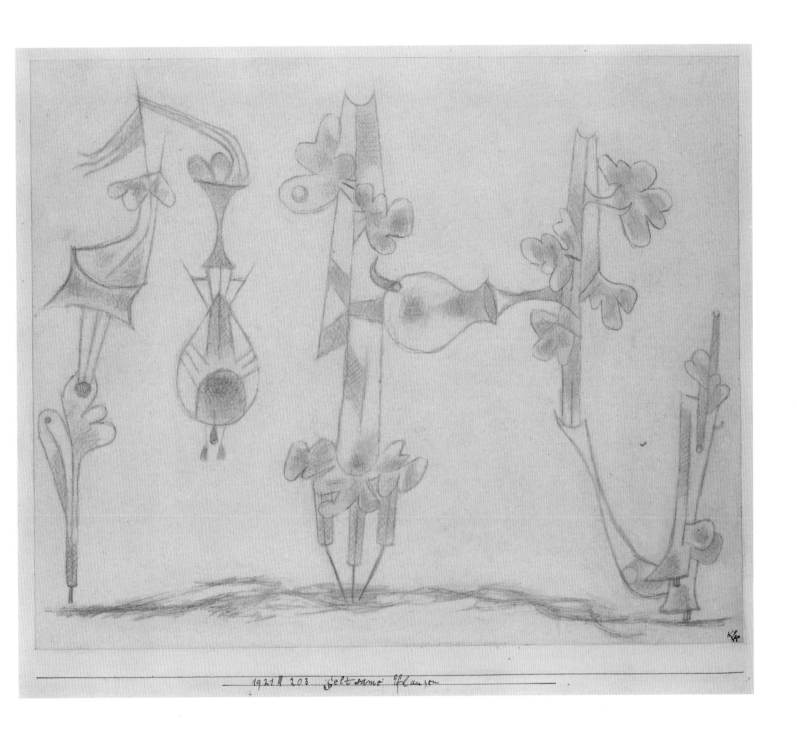

31. *Seltsame Pflanzen*, 1921 / Strange Plants

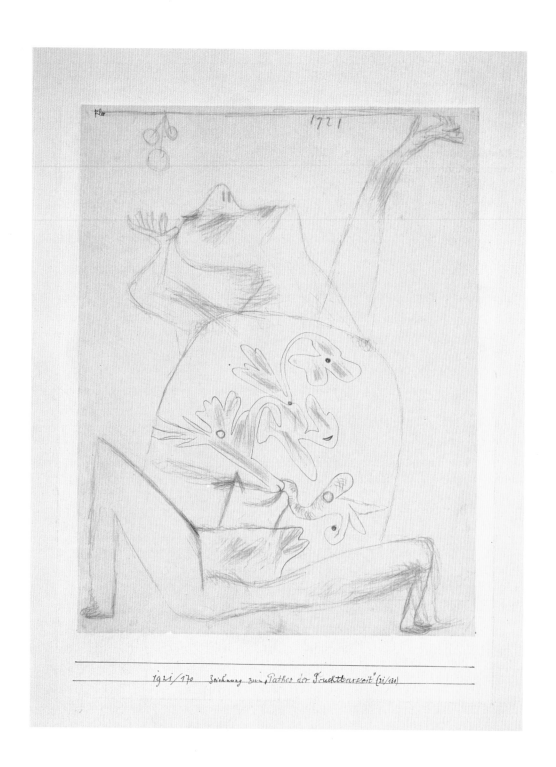

29. *Zeichnung zum 'Pathos der Fruchtbarkeit'*, 1921 / Drawing for 'The Pathos of Fertility'

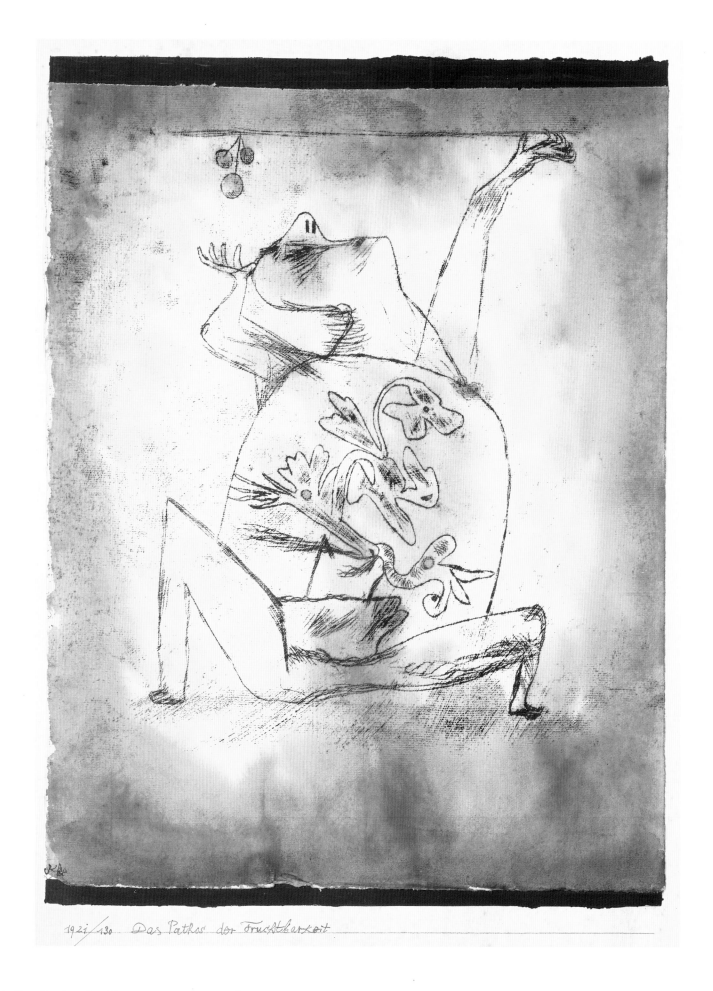

1921/130 Das Pathos der Fruchtbarkeit

26. Das Pathos der Fruchtbarkeit, 1921 / The Pathos of Fertility

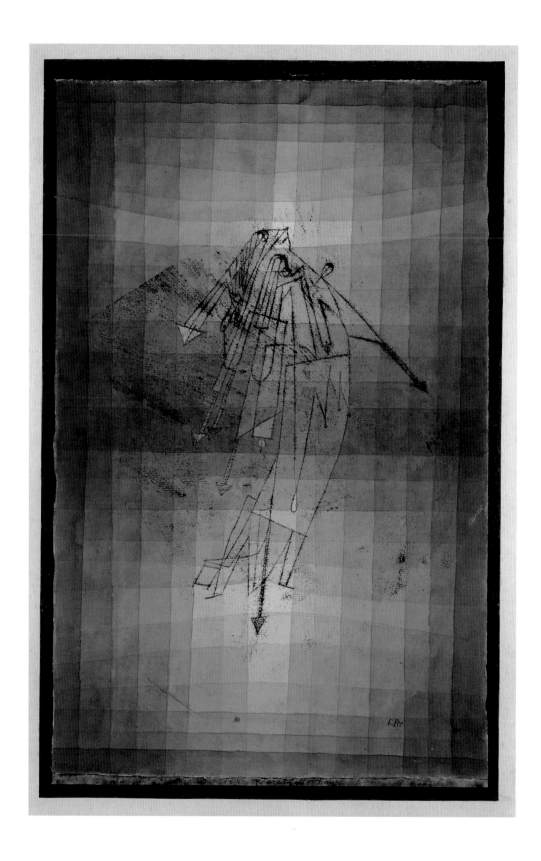

37. *Nachtfaltertanz*, 1923 / Dance of the Moth

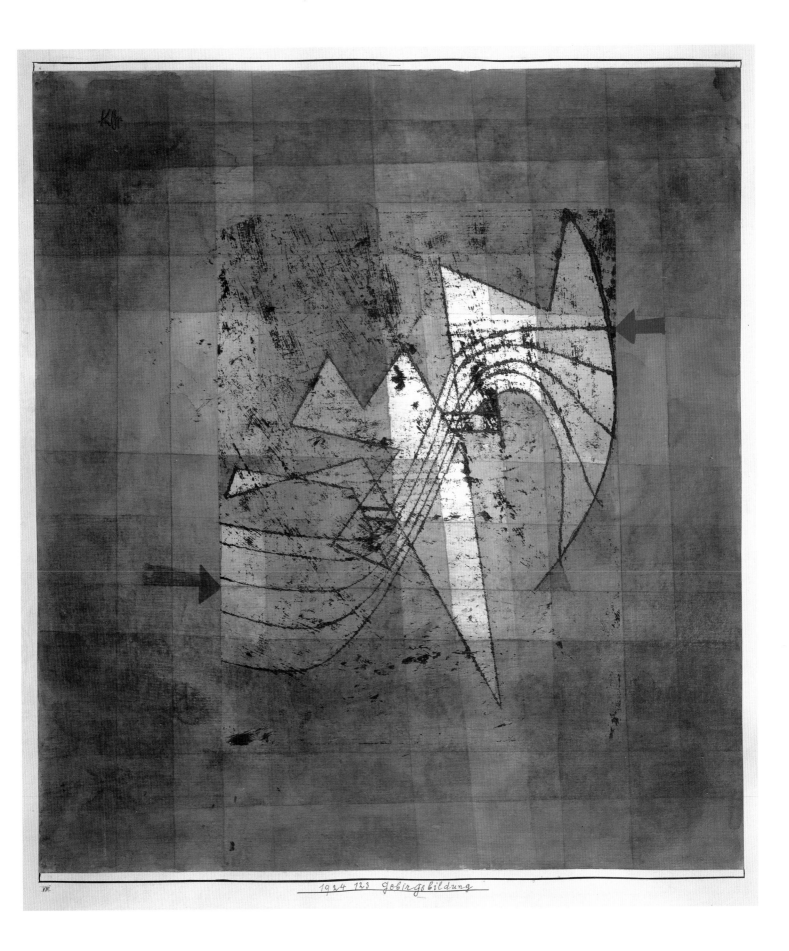

1924 123 Gebirgsbildung

41. *Gebirgsbildung,* 1924 / Mountain Formation

63. *Zauber Kunst Stück, 1927* / Conjuring Trick

25. *Hoffmanneske Märchenscene*, 1921 / Hoffmannesque Fairy-Tale Scene

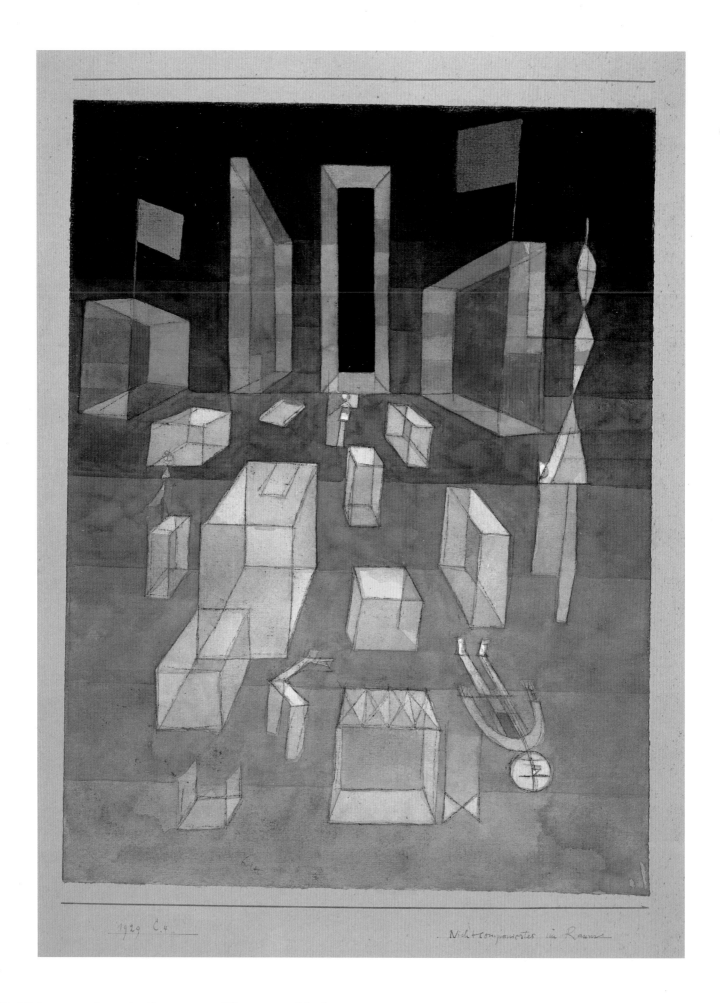

68. *Nichtcomponiertes im Raum*, 1929 / Uncomposed in Space

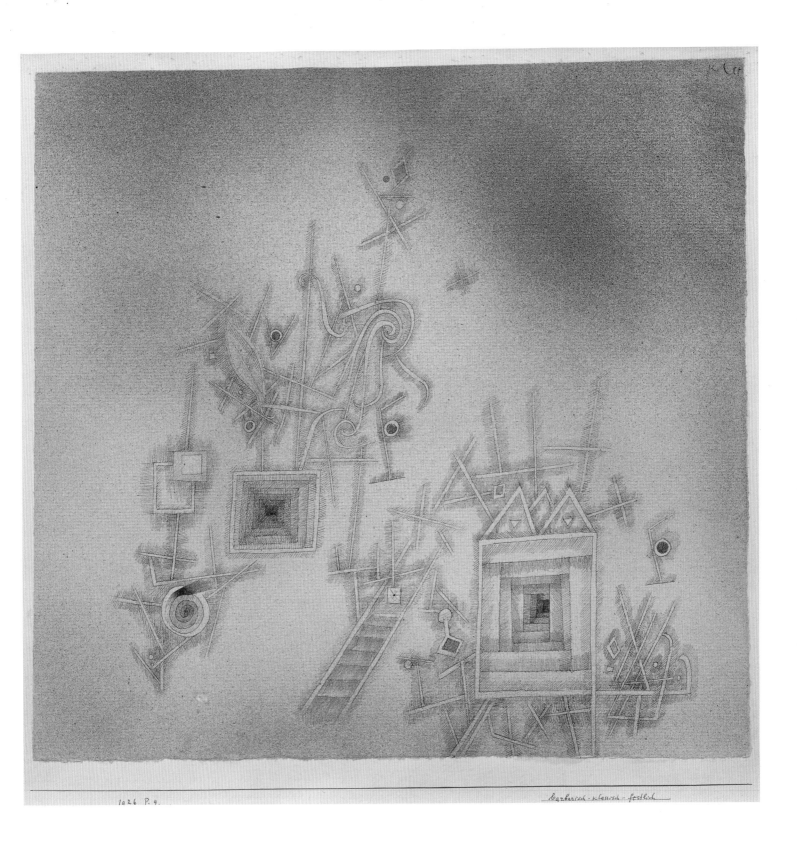

56. *barbarisch-klassisch-festlich*, 1926 / Barbarian-Classical-Festive

4

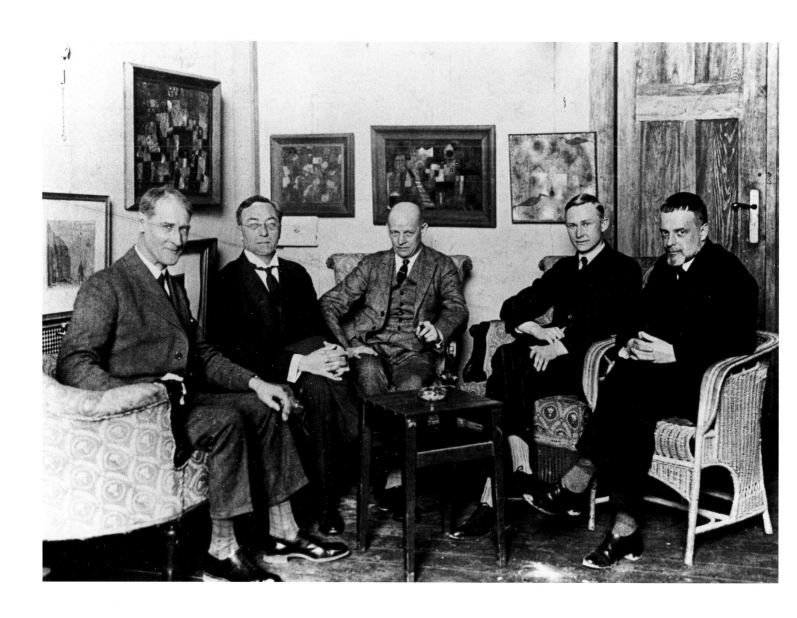

fig.13
Photograph from the heydays of the Bauhaus, Weimar (L. Feininger,
W. Kandinsky, O. Schlemmer, G. Muche, P. Klee), 1925
Archiv für Kunst und Geschichte, Berlin
Paul-Klee-Stiftung, Kunstmuseum Bern
Photo: Anonymous

The comparison to a tree already implies a sophisticated transformation of the creative impulses into a work of art. This was not always taken for granted as Klee's reference to 'the saga of the infantilism of my work' in the same lecture of 1924 indicates. Klee's drawing technique seemed to fulfil some of the expectations of a time that had discovered the aesthetic qualities of so-called Primitive art and had begun to take an interest in non-objective forms of expression, such as children's drawing and the obsessive imagery of the insane. The two first monographers of Klee, Leopold von Zahn (1920) and Wilhelm Hausenstein (1921), both interpreted his work positively under such auspices, albeit on different grounds.[36] Whereas Hausenstein, a partisan of the Left, saw in Klee's work the true endgame of a failed civilization, von Zahn stressed his combination of childlike fantasy and almost Eastern wisdom.

But such positive readings could easily be reversed, as Klee realized during the debates surrounding his nomination for a teaching post at the Academy of Art in Stuttgart. In June 1919, immediately after the collapse of the Bavarian Räterepublik, Oskar Schlemmer, acting on behalf of his fellow students, suggested to Klee that he apply for the post. Being a radical Left-winger himself, Schlemmer expected Klee to bring about an Eastern-type spiritual revolution. 'With a minimum of line he can reveal all of his wisdom. This is how a Buddha draws', he wrote in his diary as early as 1916.[37] But the public was no longer in favour of revolutionary enthusiasm. By October 1919 opinion was firmly against Klee's appointment, and not only in Stuttgart. Even Hausenstein, writing an article in Munich, warned that teaching would conflict with Klee's essential artistic quality: 'the absolute subjectivity and irrationality of his way of working'.[38] In November the application was officially rejected with the following, rather ominous, explanation: 'Mr Klee's works bear, on the whole, a playful character and in any event do not betray the strong will for structure and for pictorial construction as it is justly demanded especially by the most recent movement.'[39]

Almost exactly a year later Klee received a telegram from Walter Gropius offering him the post of a 'Master' at the Bauhaus, the recently founded State School of Art and Design in Weimar. He accepted partly because he saw that the centre of the German art scene was shifting away from Munich to Berlin, and partly because this offer accorded with a conviction he had declared in the 'Creative Credo': 'The intention is to make the accidental essential' (TE, p. 79).[40] By taking up this opportunity to teach he could show that his seemingly random way of drawing was neither subjective nor irrational, let alone childish and primitive.

This was indeed a pressing issue. Klee himself had posed it by opening his Creative Credo with the now famous statement 'Art does not reproduce the visible, but makes visible' (TE, p. 76). Where was the artist's orientation to be found when the work was no longer directed towards the thing seen? Moreover, did this way of drawing, which

dispensed with any fixed goal at its inception, not result in total arbitrariness? In his teaching at the Bauhaus, Klee gave an answer to these questions which closely echoes Matisse: it is 'the pure cultivation of the means' (TE, p. 95) that must form the new discipline of the artist.[41] With the disappearance of a common pictorial language and of traditional, practical methods, the raw objective basis of painting was exposed to those artists willing to admit it. The means of painting are not just instrumental to the result, but are autonomous factors that filter and shape the artist's intention. Though inevitably employed as means of expression, lines, colours and forms still retain a life of their own as expressive agents in the finished work.

Unfortunately this crucial point has been clouded over by misconceptions about the idea of purity. In his Jena lecture Klee made it perfectly clear that by purity he meant the analytical separation and investigation of each particular factor. 'We must avoid the slightest trace of blurring' (ibid.), he said, because only when colours, lines and forms have been analysed according to their specific pictorial capacity – how each functions alone – can they be combined in a way that is sympathetic to the needs of the painter.

fig. 14
Paul Klee
Examining
Perspective
Pages 16 and 18
from *Beiträge zur
bildnerischen
Formlehre*, 1921
Contribution to a
theory of pictorial
form
pen on paper
20.5 x 16.5 cm
Paul-Klee-Stiftung,
Kunstmuseum Bern

Of all the examples Klee gave of this new, distinctly modern approach the most striking was his introduction to perspective. Instead of regarding it as a tool to fashion a particular illusion, he used it to show how lines function perceptually (fig. 14). He began with two oblique lines leaning towards one another and crossed them with two horizontals, one at the top and one at the bottom. The emergent trapezium can be read as a scaffold or as two rungs of a ladder. It is only after subdividing the horizontals into four equal parts that a clear spatial sense results, rather like that of tracks leading into the distance. This spatial pull is increased by the repetition of the horizontal divisions

at diminishing intervals upwards. Thus a 'railway line' appears, which Klee acknowledged by crowning it with a steam engine! However, the serious purpose behind the exercise was to demonstrate the importance of the introduction of a straight vertical to direct our attention. 'It means that we ourselves have stood where it stands. (The frontal plumb line)' (TE, p.137). The repetition of the horizontals on the other hand increases the feeling of ascent and distance because, as Klee says: 'The horizontal means eye level' (TE, p. 147).

Obviously such considerations play a part in Klee's own paintings. In *Room Perspective Red/Green*, 1921 (cat. 21) the plumb line corresponding to the spectator's position is shifted to the left with a resulting distortion of the perspectival construction. *Uncomposed in Space*, 1929 (cat. 68) imposes a steady adjustment of eye level on us by the regular ascent of the horizontal divisions of the painting. Both these works deliberately avoid bringing the perspectival indications to a finite resolution. Far from becoming locked in a coherent illusion our vision adopts a 'wandering viewpoint' (TE, p. 170), and is free to discover the fluid space that it helps to generate by exploring the shifting structure of the painting.

It is no coincidence that, after Cézanne, Klee was the favourite painter of Maurice Merleau-Ponty.[42] Klee's analysis of the pictorial means was thoroughly phenomenological in the sense that the formal realities are not separated from the way in which we perceive them. In 'making visible' Klee revealed that what we see in the picture plane is never purely visual, but includes factors such as gravity and the position of our own body. The most sophisticated example of this approach is the analysis of the spiral. In its mathematical definition the spiral is a circular movement determined by either the lengthening or the shortening of the radius. But this is not how we read the spiral as a pictorial figure. In it, as Klee pointed out, we experience an elementary opposition of forces: 'It is the direction that decides whether we are being released from the centre in a movement that is ever freer or whether we are becoming more and more attached to a centre that will ultimately destroy us' (TE, p. 399).

In his scientific writings Goethe regarded the spiral as the archetypal structure of movement in living nature for this same reason.[43] It is interesting to note that Klee in his teaching in Weimar emphasized the parallelism between nature and art as only Goethe had done before him. 'Nature can afford to be lavish in all things; the artist must be thrifty in every detail. Nature is loquacious to the point of confusion; let the artist be silent and orderly … Reduce the whole to a very few steps, let the general impression rest on this principle of economy' (TE, p. 451). This did not necessarily entail a restriction of the artist's creative range, as Klee made clear when he introduced tonality as a factor fundamental to painting. He first directed the students' attention to the infinite subtlety of tonal shades in nature: 'The particles closest to one another are scarcely distinct. It is not possible to orientate oneself definitely. A locale cannot be sharply fixed, everything solid is gently but surely swept along by the flow, the fine current' (NN, p. 347). In opposition to this infinite flux the task of the artist becomes clear: 'Our need for orientation is expressed in dividing and fixing stages, precisely located; and this is done at the cost of reducing the wealth of possible nuances. Indeed, it was these many

fine gradations that confused us, as all that is natural starts out by baffling our insight, until, at some point, we reach the reassurance of an orientation' (NN, p. 352). But once this restriction to clearly defined steps had been accepted, tonal gradation could open up a multitude of sensations quite different from the initial light to dark progression, such as standing, gliding and leaping (see repr. NN, p. 349).

fig. 15
Paul Klee
*Schwankendes
Gleichgewicht,* 1922
Unstable Equilibrium
watercolour and pencil
on paper, bordered
with watercolour and
pen on card
31.4 x 15.7/15.2 cm
Paul-Klee-Stiftung,
Kunstmuseum Bern

In this way Klee structured his teaching as a gradual progression from the elementary to the complex. But the goal of his instruction was at once practical and highly speculative. It consisted of a compositional order that he saw in both nature and art: the relationship of opposites. On an elementary level this included the balancing of weights, such as light and dark; directions, such as side to side or top to bottom, and movements, such as fast or slow. The principle of this balance, however, did not lie in a static and definitive equilibrium. Many of Klee's works such as *An Equilibrium Caprice,* 1923 (cat. 39), *Tightrope Walker,* 1923 (cat. 38) or *Conjuring Trick,* 1927 (cat. 63) show that he aimed at a delicate momentary poise: the watercolour *Unstable Equilibrium,* 1922 (fig. 15) even names the principle it asserts.

There is an overt and profound affinity to the 'dynamic equilibrium' which Mondrian conceived quite independently at around the same time. Nevertheless, the speculative reflections of both artists help to clarify the divergence of their respective work. Whereas Mondrian aspired to a plastic order in which the contrasting weights, planes and colours sustain one another in a dynamic balance, Klee tried to reconcile the frictions and dissonances within an enveloping tension. As early as 1908 his diary notes:

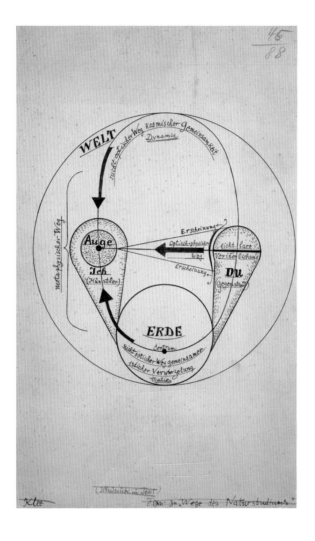

fig. 16
Paul Klee
Diagram I-You-
Earth-World
Pedagogical Writings
(PN26 M45/88),
undated
pen on paper on card
33 x 21 cm
Paul-Klee-Stiftung,
Kunstmuseum Bern
Photo: Peter Lauri,
Bern

'Only when one and two are set harshly against each other does three become necessary, in turn, to transform this harshness into harmony' (D 844). But it was only at the Bauhaus that he began to articulate this dominant harmony as an equilibrium between the static and the dynamic, the earthboundness of man versus his freedom to move about in the world.

Klee's Bauhaus essay 'Ways of Nature Study' (1923) explains this tension in a diagram that shows human life existing in three different and equally important relationships (fig. 16). Of all artists, the painter most clearly stands face to face with the appearance of nature, as subject to object. At the same time he shares two natural bonds with these

appearances: the ground, 'gravitating towards the centre of the earth' (TE, p. 67), and the cosmic sphere in which all life unfolds. In this diagram the final transformation of the conflict upon which Klee had commented ironically in *Winged Hero*, 1905 (fig. 7) is easily recognizable. The tragic conflict has been absorbed in an 'intermediate realm', the domain of the artist's creative explorations.

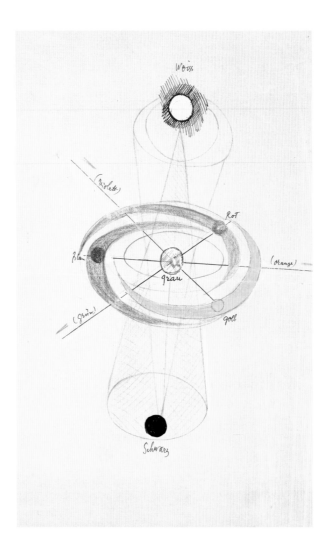

fig. 17
Paul Klee
Canon of Totality
Pedagogical Writings
(PN10 M9/29),
undated
coloured pencil, pencil
and Indian ink on
paper
27.5 x 20.7 cm
Paul-Klee-Stiftung,
Kunstmuseum Bern
Photo: Peter Lauri,
Bern

However speculative this diagram may seem, there are many practical echoes of it in Klee's work and in particular in his understanding of colour. He presented the classic circle of six colours as a disc centred in grey. Two cones interpenetrate across this centre, the upper one – indicating the active side of colour – culminates in a white light, while in the lower one colour's material properties gravitate towards black.[44] Like all diagrams of colour structure, this 'canon of totality' (fig. 17) is of course an ideal scheme. Klee warned his students against 'the impoverishment of taking the law too literally' (TE, p. 499). But in his own paintings he related the concept of unstable balance to this law successfully, as both *Static-Dynamic Gradation*, 1923 (cat. 35) and *New Harmony*, 1936

(fig. 6) show. Neither the tension between earth colours and those of the light, nor the structural symmetry of the square sequences are resolved in a static equilibrium. The solution is to be found in the very centre where both the colour harmony and the formal order are discretely veiled.

The intellectual penetration of Klee's teaching at the Bauhaus is unique in the annals of art instruction, and it was presumably overwhelming for the students. But it would be wrong to assume that the artist was simply pursuing an abstract intellectual ideal. Although it may be difficult to find a direct equivalent in the visual art of the past, Klee seems to have had a certain form of music in his mind. A skilful violin player since his childhood, the idea of unstable balance that he developed so highly was obviously modelled on the oscillating equilibrium characteristic of Mozart's, his favourite composer, music. A small incident in 1926 shows how close this affiliation must have been. The National Theatre in Weimar had once again staged a production of *Don Giovanni*, which omitted the serene final sextet and ended instead with the hero going to hell. In a letter to the conductor Klee criticized this nineteenth-century mutilation, pointing out that the simple dualism of good and evil is irreconcilable with the ultimate 'equilibrium' of Mozart's opera: 'Your finale offends my feeling because in the case of *Don Giovanni* it is as elementary as a thunderstorm. But after the thunderstorm I want to take a deep breath and, in full consciousness, see restitution.'[45] This is, in essence, Klee's aesthetic.

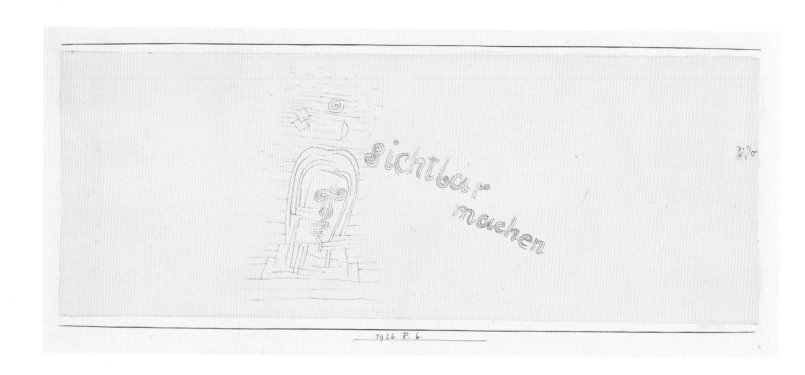

55. *"sichtbar machen"*, 1926 / "make visible"

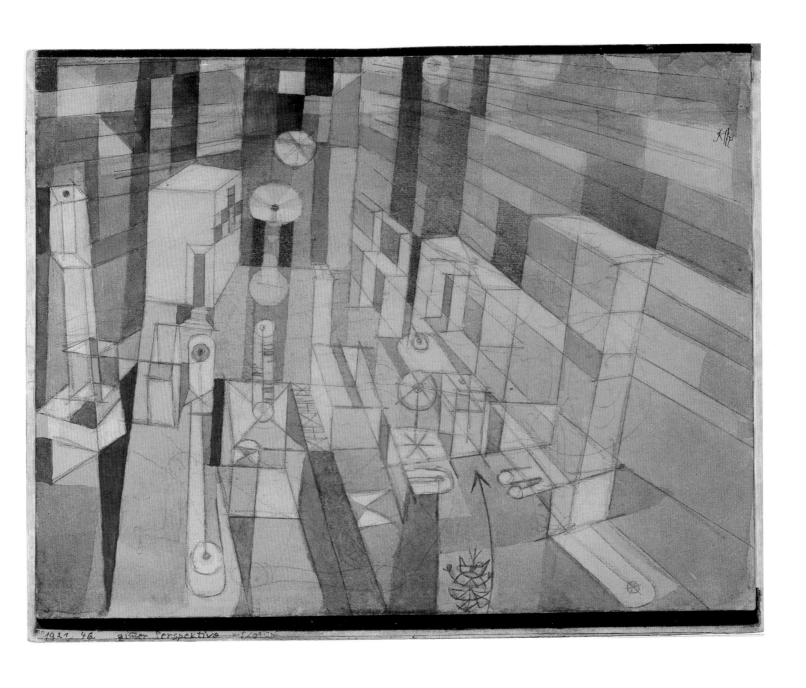

21. *Zimmer Perspektive rot/grün*, 1921 / Room Perspective Red/Green

72. *Räumliche Studie I (rationale Verbindungen)*, 1930 / Spatial Study I (Rational Connections)

1931. M.12. Beschwingtes

74. *Beschwingtes*, 1931 / Elated

75. *L'homme approximatif*, 1931/The Approximate Man

69. *Feigenbaum*, 1929 / Fig Tree

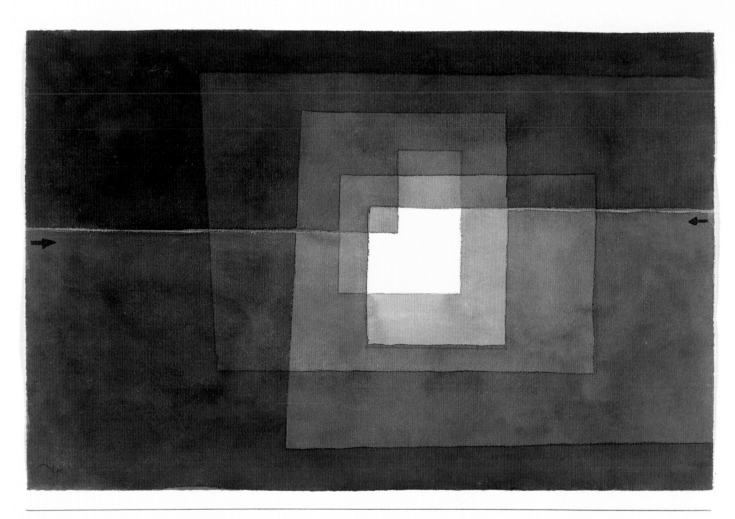

80. *Zwei Gänge*, 1932 / Two Ways

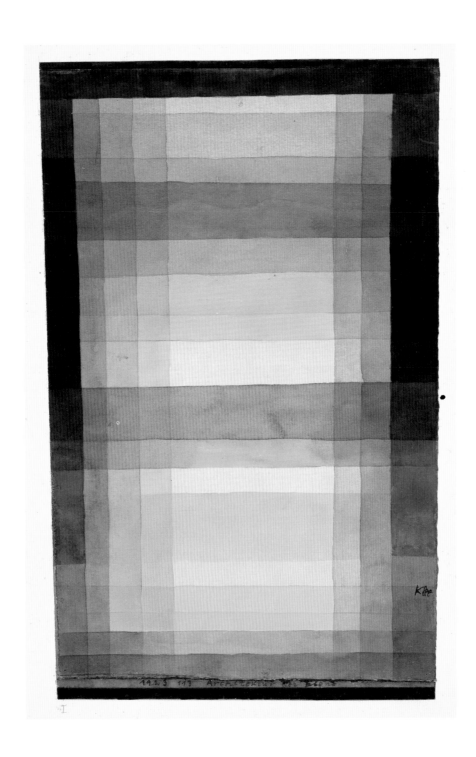

36. *Architektur der Ebene*, 1923 / Architecture of the Plain

38. *Seiltänzer*, 1923 / Tightrope Walker

39. *Ein Gleichgewicht-Capriccio,* 1923 / An Equilibrium Caprice

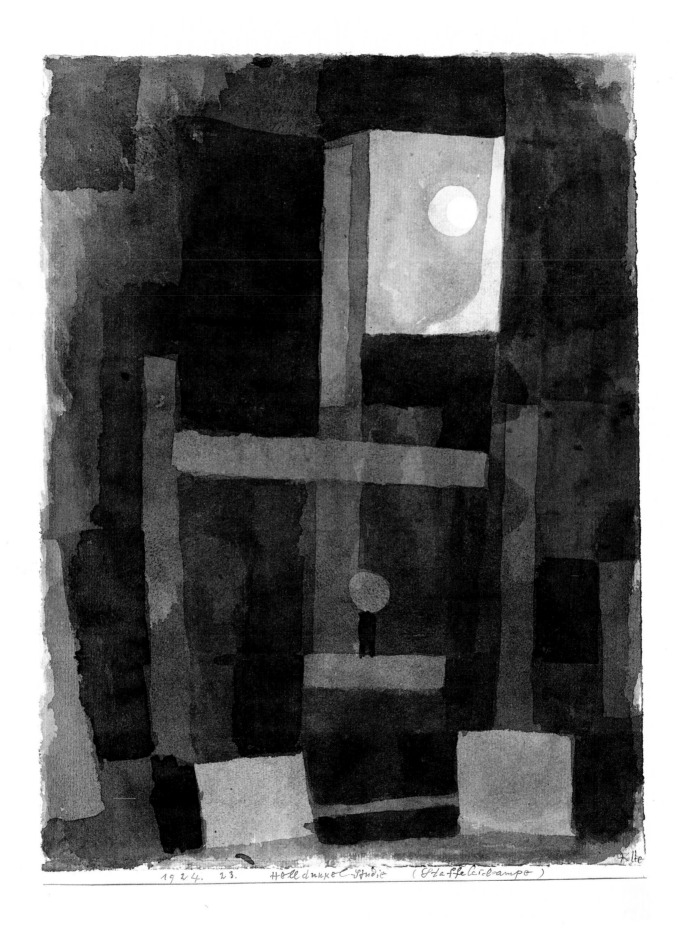

40. *Helldunkel-Studie (Staffeleilampe)*, 1924 / Study in Chiaroscuro (Easel Lamp)

81. *Spiralschraubenblüten II*, 1932 / Helical Flowers II

24. *Kristall-Stufung*, 1921 / Crystal Gradation

32. *Der Bote des Herbstes*, 1922 / Harbinger of Autumn

5

fig. 18
*In der Strömung sechs
Schwellen*, 1929
In the Current Six
Thresholds
oil and tempera on
canvas
42.2 x 42.2 cm
Solomon R.
Guggenheim
Museum, New York
Photo: David Heald
Photo © The Solomon
R. Guggenheim
Foundation, New York

'THE CENTRAL OPPOSITION DIVIDUAL-INDIVIDUAL' –

THE FORMATIVE PROCESS REFLECTED IN

LINE AND COLOUR DIVISIONISM

Whatever the students may have made of Klee's instruction, the one who learnt most was the artist himself. His own work at the time was often closely related to his teaching. In December 1921 he wrote to Lily: 'Here in the studio I work at half a dozen paintings and I am drawing and thinking about my course, everything together. For it has to go together, otherwise it wouldn't work at all'.[46] So it is not surprising that some of his most beautiful works, like *Crystal Gradation*, 1921 (cat. 24), have an almost pedagogic explicitness. Only Haydn, in the *London Symphonies*, succeeded in similarly captivating his public while demonstrating what his new music could do.

However, the one issue central to all of Klee's Bauhaus lessons could not be taught, but had to be worked out in the studio by himself: the primacy of genesis over any finite form. This insight is recorded in his diary around the critical period of 1914 to 1915: 'Genesis as formal movement is the essential thing in a work' (D 943). But it is not until 1921, when he started teaching that the distinction between 'form' and 'formation' (*Gestaltung*) became a recurrent theme (cf. TE, p. 17). In advising the 'pure cultivation of means' Klee emerged as a rigorous anti-formalist. 'We learn to look down on formalism and to avoid taking over results', he wrote in his essay 'Exact Experiments in the Realm of Art' (1928, TE p. 69). And in his 1924 Jena lecture he even justified the controversial distortions of Modern art as the artist's involvement with the natural creative process: 'He is more concerned with the formative powers than with finished forms' (TE, p. 92).

The documents of the 1920s prove that Klee's declared position, 'closer to the heart of creation than usual, and still not close enough', was not mere poetic fantasy. The exacting degree of intellectual penetration in his practice is astonishing. On all levels Klee insisted upon the priority of the living connection with the creative process. Far from being restricted to the studio this attitude took on a wider significance. 'Do not define today', he warned his students, 'define backwards and forwards, spatial and many-sided. A defined today is over and done for' (TE, p. 59). But the most crucial application of this concept concerns the status of completion in a work of art. The familiar idea of a painting being primarily a static object in space was challenged. 'The work of art, too, is first of all, genesis; it is never experienced purely as a result' (TE, p. 78). Klee is the first great modern artist to state the basic temporality in the perception of a painting: 'For space itself is a temporal concept' (ibid.).

The radical nature of these insights made one crucial problem clear: how to make this universal process visible? The Romantics had already laid claim to the pre-eminence of process as an artistic problem. Their solution was to 'romanticize' reality by dissolving limits and legitimising the fragment.[47] But these would not have been 'appropriate

means' in Klee's terms, because the Romantics propagated the impossibility of grasping and defining the living process as a form of expression in itself. Klee's 'cool Romanticism' is perhaps best characterized by his realization that genesis is not just an unlimited flux, but a force continually moving between formation and dissolution. And indeed, that interplay can be articulated. The plastic equivalent that Klee worked out in his Bauhaus years is the opposition between an endlessly divisible continuum, which he called 'dividual', and individual form.

fig. 19
Paul Klee
Reconstruction of the connection between *Red and White Domes*, 1914 (cat. 5) and *In the Desert*, 1914 (*In der Einöde*)
watercolour on paper
17.4 x 13.9 cm
Collection Dr Franz Meyer, Zurich

Like most of Klee's mature conceptions this distinction had been anticipated in his practice. There are many drawings in which the contours of forms are deliberately repeated and multiplied to avoid any finite circumscription, and the device of squaring up the pictorial field was in itself a first attempt at a divisible continuum. Moreover, recent research has brought to light a number of works in which Klee cut up a seemingly finished piece and reworked the parts.[48] *Red and White Domes*, 1914 (cat. 5), for instance, was originally wider on the right, before Klee removed a section, developing it into *In the Desert*, 1914 (fig. 19). Far from being simply a way of editing, this method of dividing and reworking a composition – commonplace in music – is paralleled in the visual arts by Constantin Brancusi. The sculptor of the *Endless Column* also on occasion took part of a larger configuration and rethought it as an individual piece.[49]

But Klee was unique in turning this practical approach, in the mid-1920s, into a structural principle. Shortly after the Bauhaus moved to Dessau in 1925, he began work on a group of drawings and paintings in which the interplay between specific formal accents, or nuclei, and continuous 'parallel figuration' was paramount. The potentially limitless extension of this repetitive structure can be articulated in two different ways, depending on the individual distinctions. It may evoke the sensation of growth and

expansion as in *Forest Architecture*, 1925 (cat. 50), where trees seem to compete in generative power, or the reverse: in *Lonely Flower*, 1934 (cat. 82) the circular extension seems to be almost turned back in on its own centre. As in nature, this repetitive layering can also be expressive of states of compression and accumulation, as, for instance, in *Rock-Cut Temple*, 1925 (cat. 49) or *Place of Worship*, 1934 (cat. 84).

Between these poles of expansion and contraction, compression and stratification Klee developed a multitude of different characteristics, all of which interpret the basic concept of formation. Even ephemeral constellations of forces like *Spring in the Stream*, 1934 (cat. 85) or *Play on the Water*, 1935 (cat. 86) embody this idea. But it takes a highly evocative work such as *View of a Mountain Sanctuary*, 1926 (cat. 52) to realize the surprising cultural analogy that Klee involuntarily opened up through this very personal method of drawing. His vision of a generative force, infusing and permeating all forms of existence, is a close approximation to the ancient Eastern concept of nature. Because of its distinctly western rationale, Klee's 'parallel figuration' can be seen as a genuine equivalent to those folded 'dragon backs' in the landscapes of early Chinese ink painting (fig. 20).

fig. 20
Ch'en Ju-yen
The Woodcutter of Mount Lo-fou, 1366
hanging scroll,
ink on silk
106 x 53.3 cm
The Cleveland
Museum of Art
Gift of Mrs A. Dean
Perry (1964.156)
Photo © The
Cleveland Museum of
Art, 2002

This affinity also helps to clarify Klee's frequent use of the biblical terms genesis and creation. In his understanding, the notion of the creative spirit is obviously, as *Creator II*, 1930 (cat. 71) indicates, not connected with the image of an omnipotent creator. Serenely floating in space this unearthly figure, impenetrably wrapped up in itself, is a charming comment on the Almighty Father at the centre of Michelangelo's Sistine ceiling. But Klee does not cast the artist in this role. The small pencil drawing *"make visible"*, 1926 (cat. 55) presents an anxious head whose features are extended by parallel lines, concentrating and at the same time radiating energies. It is a perfect image of that 'cosmic point of reference' (D 1008) which Klee saw as his artistic position.

One needs to appreciate both the immensity and the modesty of this claim to understand the seemingly paradoxical role that finiteness plays in Klee's work. For him, completing each particular work to and within its limits was not an undue restriction of the generative process, but an essential condition of actively participating in it, of keeping it alive. From the beginning of the 1920s, he frequently made this tension explicit by multiplying the edges of his works, framing, mounting and double mounting, and even including the straight line on which he wrote the title, almost as though he was saying: this can be resolved so far – and now the next work has to commence.[50]

In this way the direct opposition between a divisible continuum and individual forms had in itself only a limited span of life until it gave way to one of the many variants within its premise. Following a journey to Egypt in the winter of 1928–29 Klee began work on a group of images in which the extension of parallel lines was replaced by a progressive subdivision or unification – whichever way one views it. The painting *In the Current Six Thresholds*, 1929 (fig. 18) is the key example of this kind of organization. The principle seems to be the splitting of a horizontal unit at six vertical breaks into a successive progression of one, two, four and eight; or, read in reverse, the steady gathering up of the slender narrow compartments into increasingly larger blocks. Apart from being compositionally displaced, this geometric progression is masked by a subdued colour harmony consisting of a brownish purple-red chord supported by blue-violet and thin lines of yellow. As a result, the sequential structure of the painting may also be seen as a perfectly poised 'unstable equilibrium', tightly packed on the left versus spaciously resonant on the right.

Such different layers of reading are of course a reflection of the formal language itself. Although geometric progressions have a direct correspondence in nature, as Klee himself showed in the undated study *Growth and Ramification* (cat. 3), in painting they do not necessarily represent this principle. In *Castle of the Order*, 1929 (cat. 66) this structural device is employed to articulate the contrast between the solidity of the architecture and the atmospheric dispersal surrounding it. Yet another function is achieved in the etching *Old Man Reckoning*, 1929 (cat. 67) where the subdivisions serve as the tonal shading around the figure, with the delightful side-effect that some of the most minute divisions take place between the man's calculating fingers.

Sometimes it needs only a small shift to make one aware of how closely connected Klee's methods are. In the watercolour, *Portrait of Mrs Gl.*, 1929 (cat. 65), progressive

subdivision is suspended in favour of a free displacement of the varying intervals along and around the loosely drawn contours (two of which – the capital 'G' encircling the breasts and the smaller 'l' in the neck – presumably inspired the title). There is an obvious connection with other 'dividual' organizations, such as the step-by-step progressions in *Harbinger of Autumn*, 1922 (cat. 32), which are based on colour gradation. But in *Portrait of Mrs Gl.* Klee works with a predominant colour-contrast – yellow and violet-pink underpinned by red and shades of ochre – which seems to anticipate the colour divisionism of the 1930s.

Superficially it may look as though the main developments in Klee's work of the 1920s were formal and linear. But one should remember that the basic element in his creative thinking was the point; the line was only 'the point that set itself in motion'. So it is not surprising that there are also works such as *Barbarian-Classical-Festive*, 1926 (cat. 56) in which he tried to subdivide the line by itself, as it were, dissolving it into a sort of crystalline string of minute parallel strokes. Set in a thinly sprayed ground of pink and blue this approach makes it clear that Klee's pointillism of the early 1930s did not originate in Neo-Impressionism but in the attempt to employ the point as a colour vehicle.

Again, there were so many premonitions that one wonders why Klee did not pick up this thread before 1930. In principle the pointillist method was already implied in the square paintings, and indeed there are many works of the 1920s in which the grid accommodating colour is minimized to a dense mosaic and sometimes even scale-like structure. Nevertheless there was good reason why Klee for a long time preferred to use this granular colour fabric as a ground, instead of bringing it forward as the dynamic plane of the painting. *Spring Painting*, 1932 (cat. 79) is, in terms of colour, a fully achieved work. The subtle blend of greens, blues, yellow-ochres and bluish pinks emanates a pale, opalescent light which, as Klee does not confine himself to the pure hues of orthodox optical mixture but also includes shades of earth colours, is all the more suggestive of the natural sensation indicated by the title. But the constructive linear divisions and areas in which these spots are placed remain relatively unrelated to colour's innate tendency to spread and disperse its energies. The same is true of the watercolour *Reflections in the Dark*, 1932 (cat. 78) in which Klee has inverted the light situation. Moreover, the fully abstract work *Two Accented Layers*, 1932 (cat. 77) reveals that he was clearly aware of the compositional problem. The introduction into the even pointillist field of two solid horizontal bars adds the weight and tension that the point by itself would not provide.

And yet, the many different levels on which Klee pursued his work allowed him to turn this deficiency to an advantage. In *Crosses and Columns*, 1931 (cat. 76) he combined an underpainting of broad colour patches with the pointillist structure in such a way that both layers partly converge and partly separate. Into these fluctuating layers go strong linear accents: columns that suggest heavy weights above and crosses that seem to be anchored to the ground. These three levels of figuration interact with and against each other like different voices in music, in a way that Klee himself properly termed 'polyphonic'.

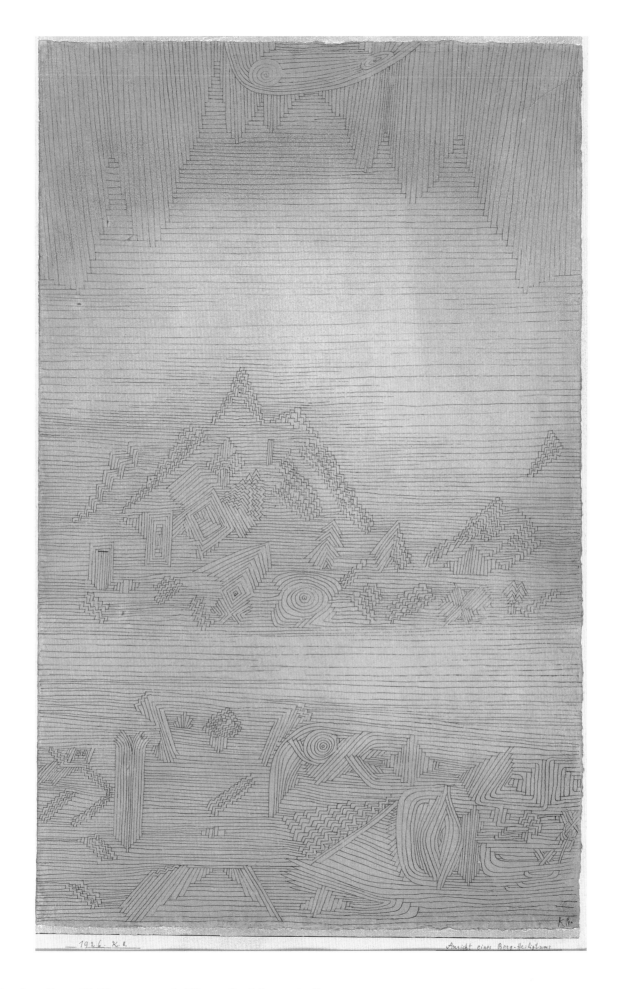

52. *Ansicht eines Berg-Heiligtums*, 1926 / View of a Mountain Sanctuary

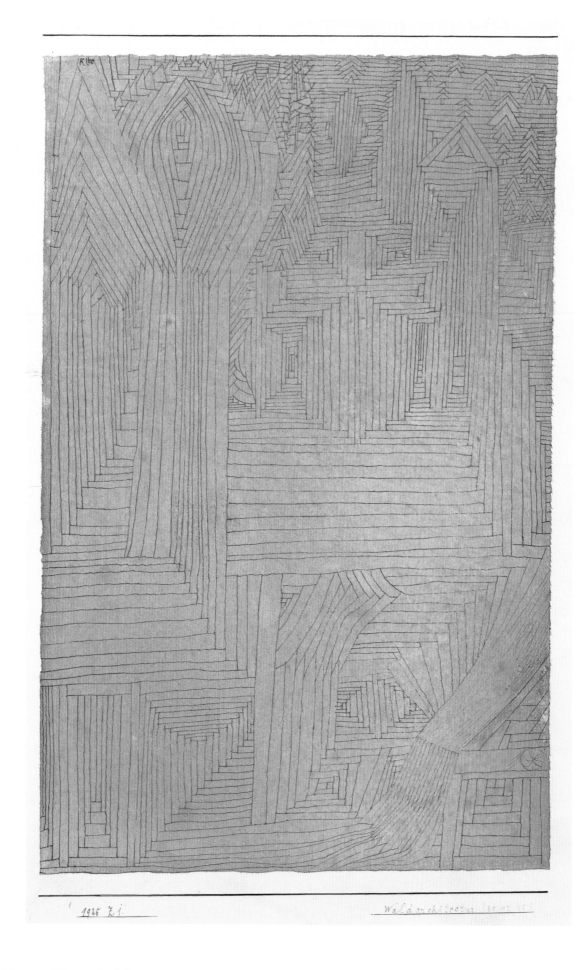

50. *Waldarchitectur* / Forest Architecture

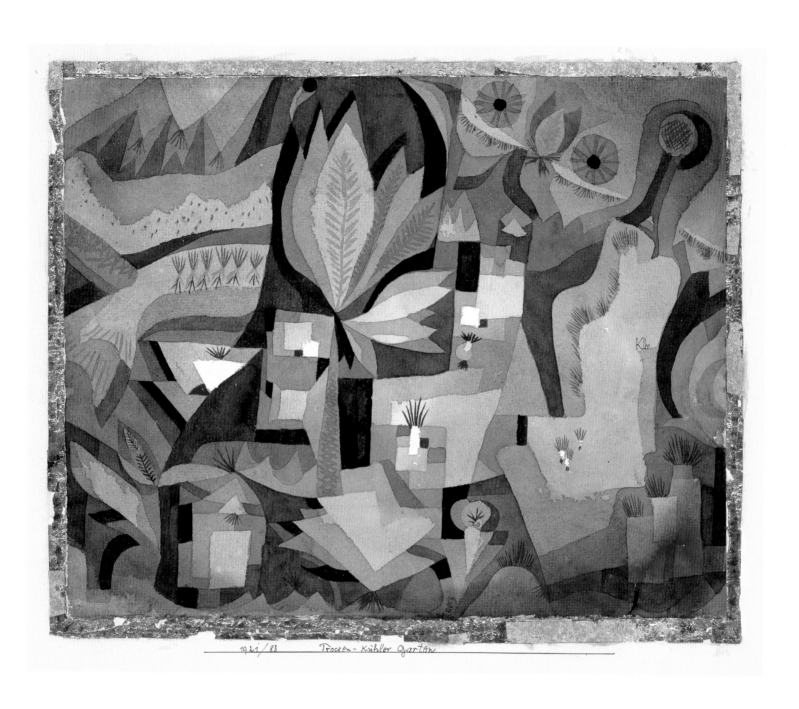

23. *Trocken-Kühler Garten*, 1921 / Dry-Cool Garden

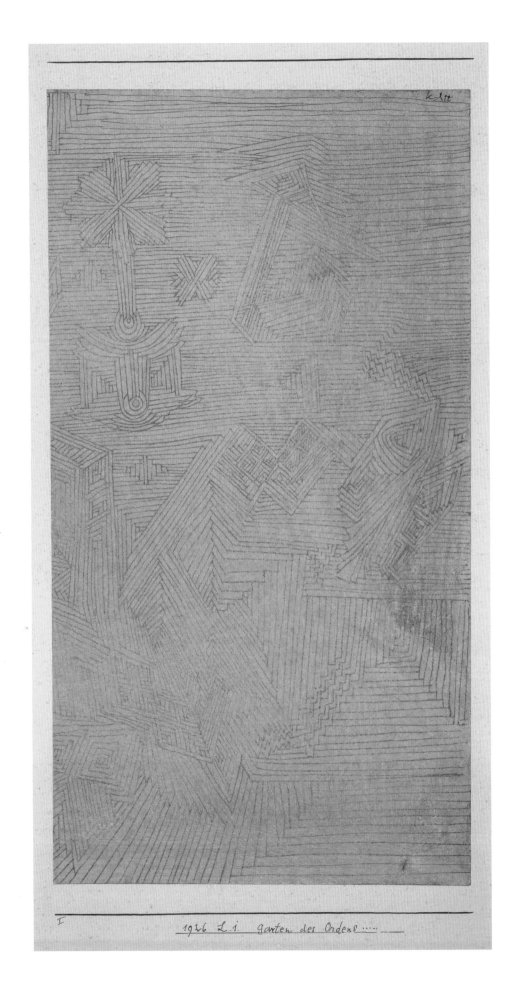

53. *Garten des Ordens*, 1926 / Garden of the Order

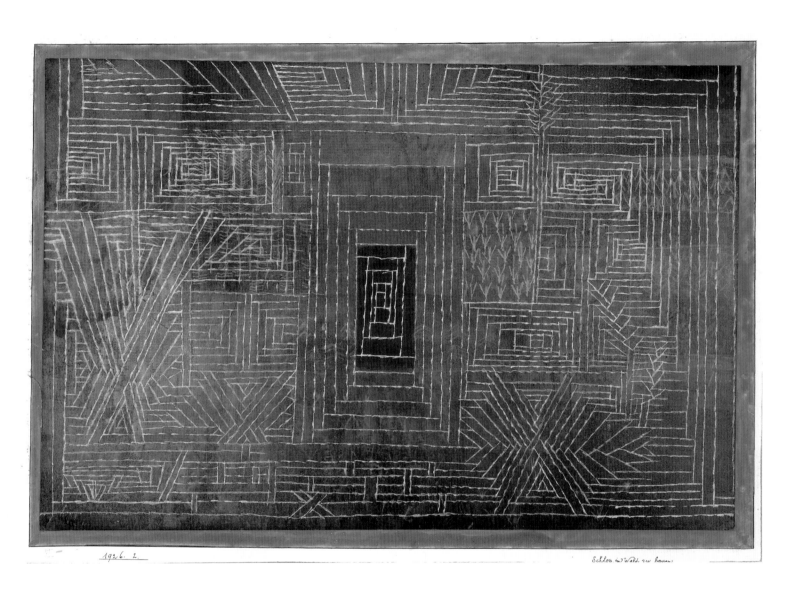

51. *Schloss im Wald zu bauen*, 1926 / Castle to be Built in the Woods

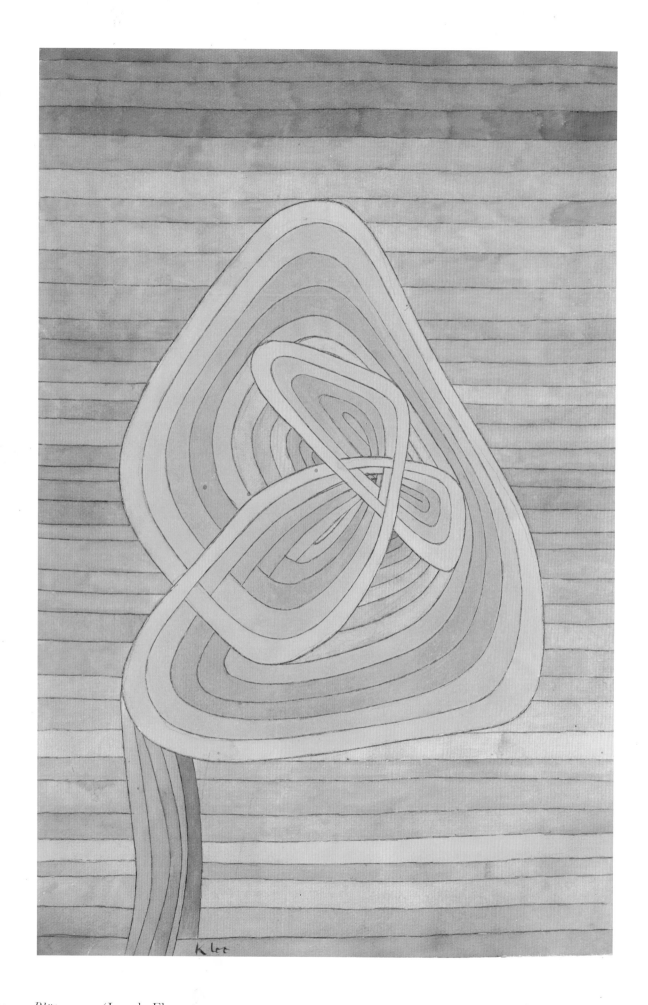

82. *Einsame Blüte*, 1934/Lonely Flower

1. *Schichtung genetisch angewendet* / Stratification Applied Genetically, undated (Pedagogical Writings)

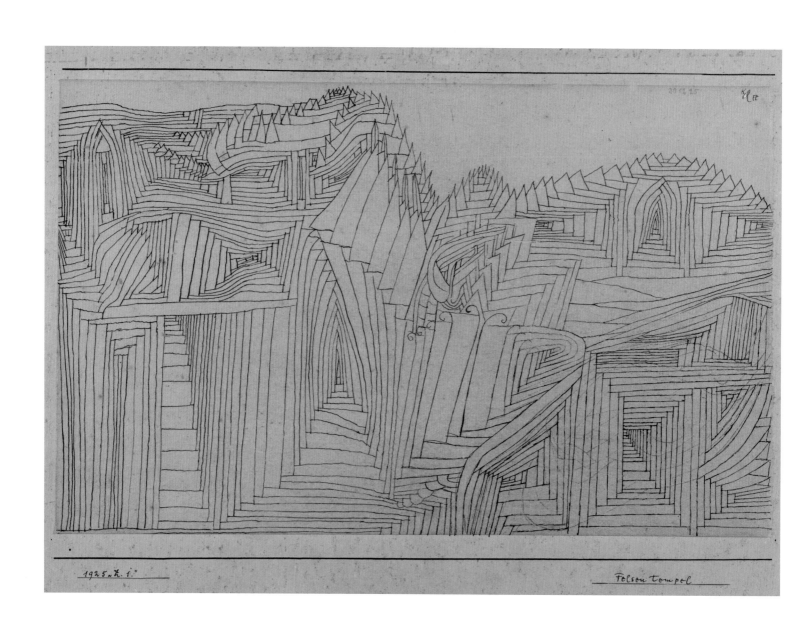

49. *Felsen Tempel*, 1925 / Rock-Cut Temple

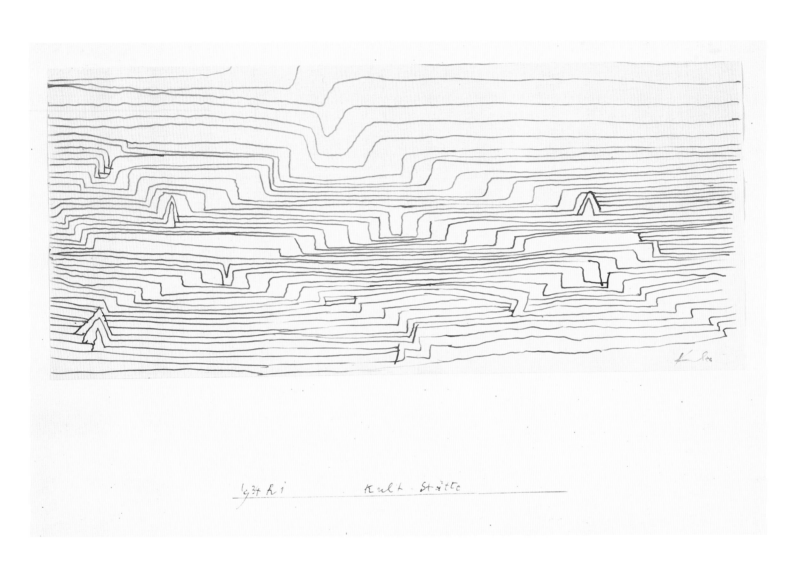

84. *Kult-Stätte*, 1934 / Place of Worship

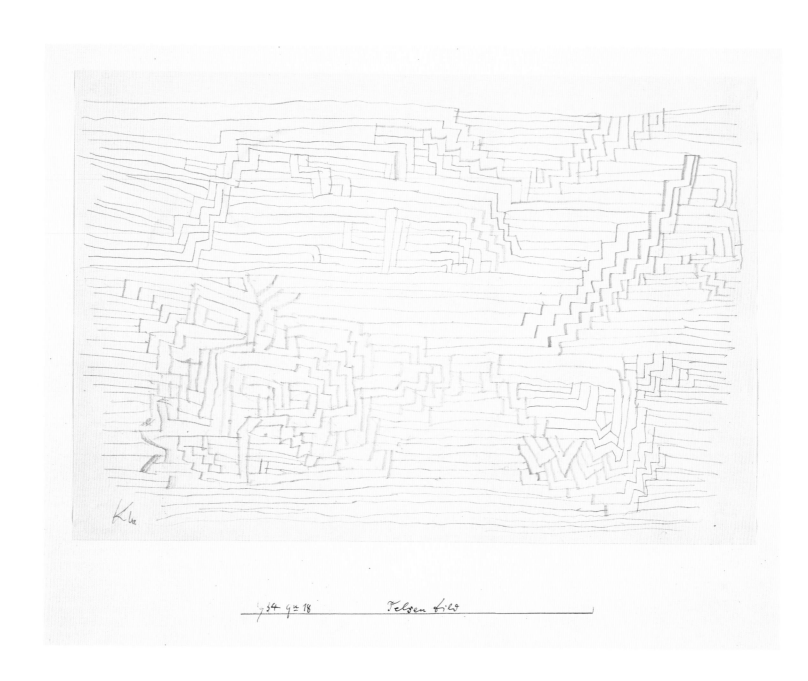

83. *Felsenbild*, 1934 / Rock Picture

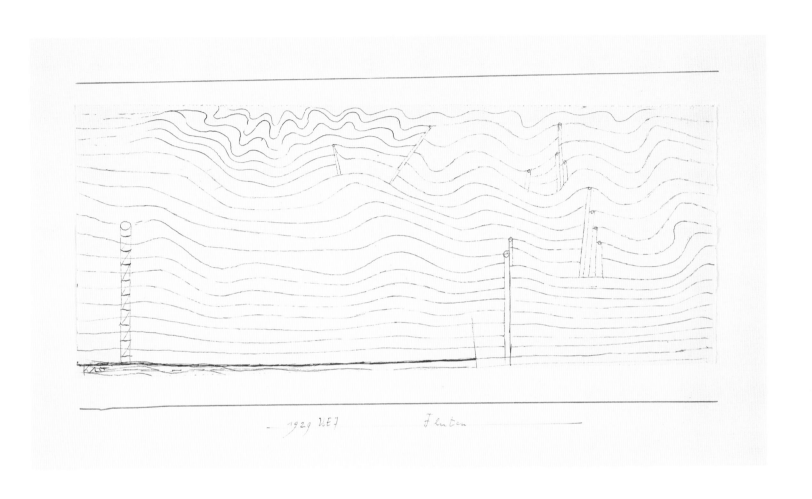

70. *Fluten*, 1929 / Floods

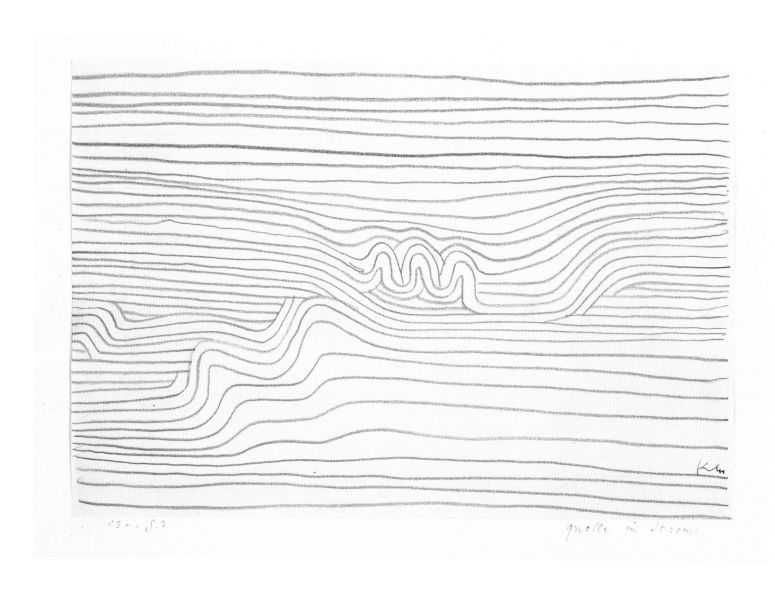

85. *Quelle im Strom*, 1934 / Spring in the Stream

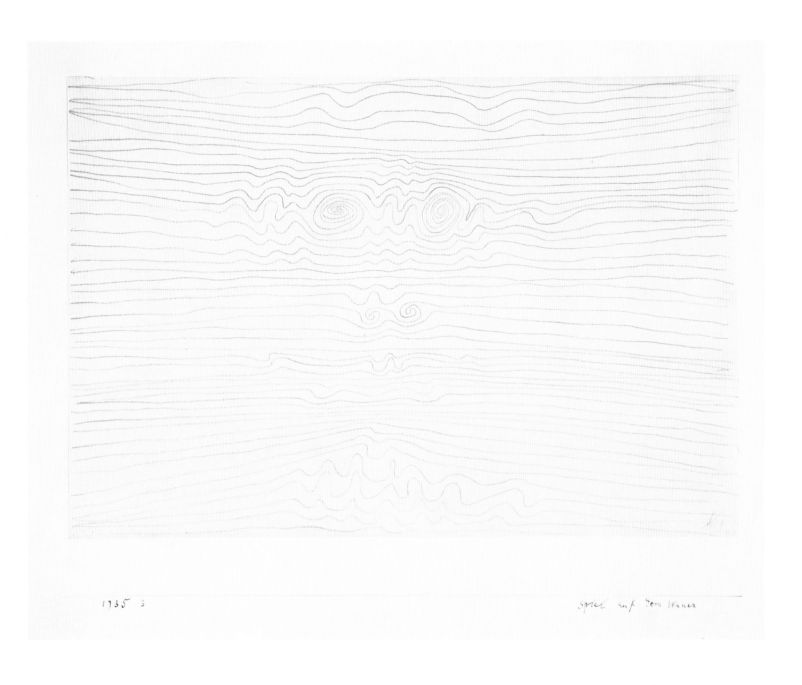

1935 3

Spiel auf dem Wasser

86. *Spiel auf dem Wasser*, 1935 / Play on the Water

121

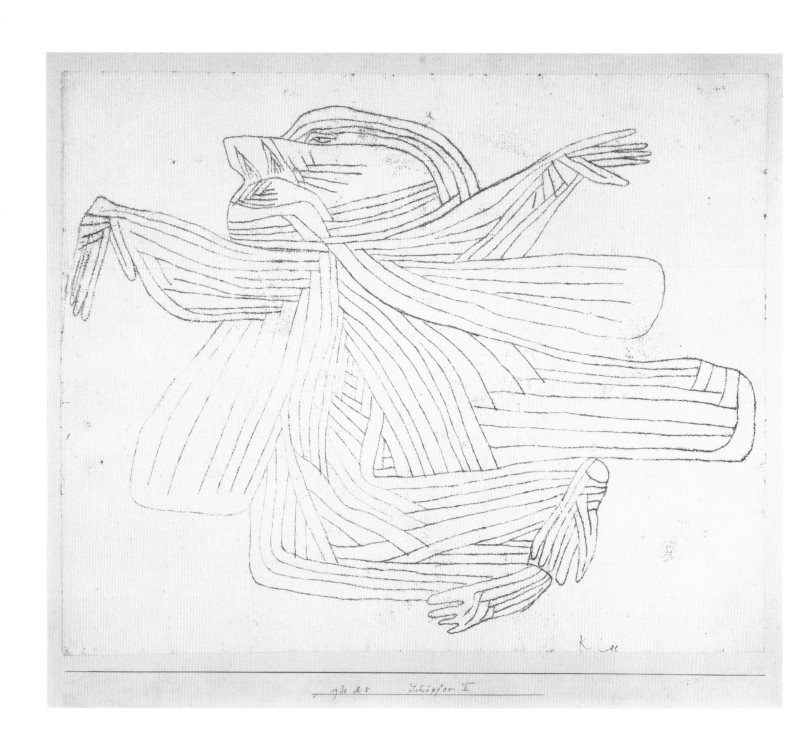

71. *Schöpfer II*, 1930 / Creator II

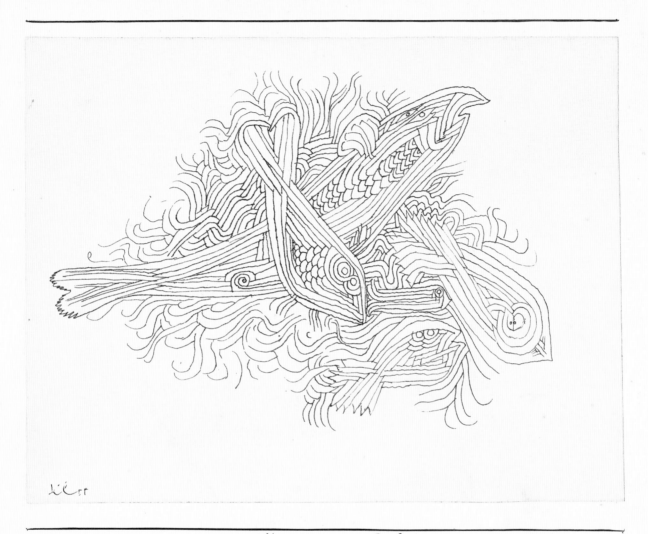

54. *Fische im Wildbach*, 1926 / Fishes in the Torrent

3. *Wachstum und Verzweigung* / Growth and Ramification, undated (Pedagogical Writings)

2. *Natürliches Wachstum und progressive Lagenfolge* / Natural Growth and Progressive Layer Sequence, undated
 (Pedagogical Writings)

66. *Ordensburg*, 1929 / Castle of the Order

67. *Rechnender Greis*, 1929 / Old Man Reckoning

65. *Bildnis Frau Gl.*, 1929 / Portrait of Mrs Gl.

1932. 6. Zwei betonte Lagen

77. Zwei betonte Lagen, 1932 / Two Accented Layers

78. *Reflexe im Dunkeln*, 1932 / Reflections in the Dark

79. *Frühlingsbild*, 1932 / Spring Painting

76. *Kreuze und Säulen*, 1931 / Crosses and Columns

6

fig. 22
Paul Klee
Ad Parnassum, 1932
oil on canvas
100 x 126 cm
1932-274 (x 14)
Paul-Klee-Stiftung,
Kunstmuseum Bern

With the pointillist paintings of 1932 Klee's work reached a certain culmination and, as it were, held its position. The major work of this group, *Ad Parnassum*, 1932 (fig. 22), is, like *Main Way and Byways*, 1929 (fig. 3), a declaration of both intent and achievement. In different ways these two paintings embody Klee's view of his development as an artist. Whereas *Main Way and Byways* emphasizes the close interrelationship between advancing and extending, *Ad Parnassum* discloses the paradox between starting point and goal. The doorway in the foreground is as prominent as the mountain above and yet no path stretches between them, only the precious tapestry of a myriad coloured touches, glittering and glimmering in the half-light. But this indeterminate moment between dawn and dusk leaves one question open: What was the inner drive that helped to unleash such riches of expression? It is obvious that there is a connection between all the major groups of works undertaken since 1914. But mere formal analysis does not touch the nerve of either the 'extreme fecundity' (Duchamp) nor the powerful conviction of what are sometimes very small and unpretentious works. The usual answer to this is, of course, 'genius'. In Klee's case, however, this all too bland response can be further qualified because the artist left an unmistakable clue in the achievement itself.

Common to all of Klee's paintings and drawings, yet quite independent of their formal or thematic pre-occupations, is a particular sense of rhythm that imbues them with their liveliness. Although this may be traced back to his prodigious talent as a musician, it is not enough to treat this particular sensitivity as though it were merely a natural disposition. Klee's remarkable artistic intuition was carefully trained, and the proof of this is his early musical criticism, partly published in the press,[51] partly contained in the letters written to Lily – herself a professional pianist – during their engagement. These documents reveal an impeccable musical taste and they deserve deeper, more scholarly consideration than they have so far received, for we find in them the origin of an artistic judgement which was to guide Klee through dangerously unprotected areas of visual expression.

Possibly the clearest and most telling sign of this musical education is his supreme indifference to the objection of distorting our vision. He is so familiar with the musical technique of transposing creative material into other scales, modi, tempi, or rhythmic registers, that he can freely subject a landscape motif to a formal grid which replaces the habitual view of space with a prismatic colour structure, as in *Landscape with the Yellow Steeple*, 1920 (cat. 17). The same procedure of transposition is used in *The Great Emperor Rides to War*, 1920 (cat. 18) where the extreme horizontal distortion of the linear register ridicules the monumental upright stance of the figure. 'In its present form it's not the only world possible,' Klee wryly remarked of such transpositions. 'This world looked different and in time to come it will look different again' (TE, p. 92).

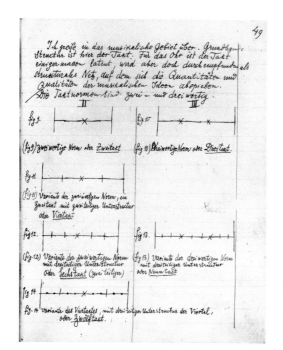

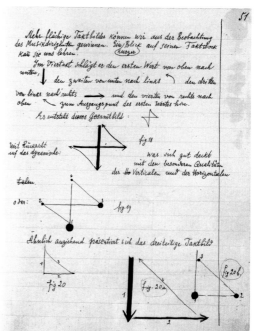

The most important residue however of Klee's musical intelligence is his introduction of visual rhythm as a manifestation of universal movement. Throughout the 1920s there are steady undercurrents of rhythmic figurations in his work which are reflected in his teaching (fig. 21A). *Drawing Knotted in the Manner of a Net*, 1920 (cat. 16) can be seen as the raw state from which the rhythmic potential emerges. The spontaneous stringing together of loosely drawn horizontal lines does not yet result in a visual movement, but the energetic drive, the divisions, the repetitions, the weights and accents which make up a rhythm are all present. In *ARA "Cooling in a Garden of the Torrid Zone"*, 1924 (cat. 46) these very same factors have been organized into a perfect example of graphic rhythm. The whole area is divided by horizontals at differing intervals, not unlike staves in a musical score, and into this signs and ciphers of different character and weight are inserted in varying forms of repetition. The little drawing contains almost all the rhythmic distinctions that Klee has analysed in great detail: the simple repetition of individual units, regular alternations, changes of structural character, syncopated overlapping and irregular frictions. Only the plain 'dividual' iteration – such as a diagonal criss-crossing, for instance – is missing.

In his Bauhaus teaching Klee made it clear that the opposition between 'dividual' and 'individual' is not the same as the distinction between rhythmic and non-rhythmic. Repetitive divisions alone do not constitute a rhythm, and the regular repetition of an individual mark simply renders it indistinguishable. 'Pure ornament is governed by primitive rhythmics (dividual or sometimes individual), it has no rhythmic relation to the inner creative drives of man' (TE, p. 229). In order to perceive something as rhythmic, a balance has to be set up between a regular element and irregularities, or as Klee says, between 'norm' and 'a-norm', between a 'major' dominant and 'minor' variants. Only through this tension can a repetitive structure be perceived as rhythmic, 'when the eye brushes past line after line' (NN, p. 83).

It is easy to see that all of Klee's explicitly rhythmic drawings and paintings work in this way, combining mechanical repetition with shifts of weight and character which are either organic, prompted by handwriting, or arrived at through intentional change. In accordance with this an ambivalence of sensation is created which the painting *Pastorale (Rhythms)*, 1927 (cat. 59) reflects in its title: are these rhythms echoes of nature or are they cultural inventions? Klee obviously courted this ambivalence, as the many titles referring to cultivation hint and the material treatment of some of these rhythmic scores underlines. Paintings such as *Tablet of the Young Wood*, 1926 (cat. 57) and *"Florentine" Residential District*, 1926 (cat. 58) show the same heavily worked ground as *Pastorale (Rhythms)*, into which their structures are literally incised.

At the other end of the spectrum, the relationship between cultural and natural rhythms is emphasized by re-casting the movements of a musical conductor as drawing. Although the equation is never literal it is clear that quite a few of the swift, almost weightless configurations are derived from the movement of directing a three-time or four-time beat (fig. 21B). The sweeping triangular strokes in *Sailing Boats, Gently Moving*, 1927 (cat. 60) are perfect examples of both the correspondence with conducting a three-time beat, and of the significant difference that the accentuated beat is shifted from the vertical to the drawn-out horizontal of the sailing boats. Such transformations can be developed into complex rhythmic structures, as in *Family Walk*, 1930 (cat. 73) where the direct musical analogy is lost in contrasting movements shuttling to and fro.

With these script-like images Klee obviously had a strong influence on the development from Surrealism to gestural Abstraction as practised by artists like Henri Michaux and Mark Tobey. One can see in Klee's rhythmic scripts premonitions of the all-over structure of American Abstract Expressionism, except that his works always show an acute awareness of the limited potential of the energetic forces involved. Whether it is the filigree writing of *A Leaf from the Book of Cities*, 1928 (cat. 64), the heavy pounding of *Rose Garden*, 1920 (cat. 12), or the distorting tensions in *Ripe Harvest*, 1924 (cat. 45), it always seems as though what we see has been precisely tuned to the measure of perception by a special musical intelligence.

Or perhaps one has to pick up the other end of the analogies provided by Klee in his rhythmic compositions: 'Il faut cultiver le jardin'. There is a way of dealing with the creative impulses which is clearly reminiscent of the work of a gardener who cultivates and tills, plants and prunes, cuts and grafts. For instance, the comparison between *Flower Garden*, 1924 (cat. 44) and *Horticulture*, 1925 (cat. 47) shows a certain species of recurrent signs and marks, which have obviously been developed, transplanted and re-grouped. The mature Klee seems to come close to artists such as Brancusi and Matisse who introduced the ethos of the gardener into the world of plastic autonomy.

17. Landschaft mit dem gelben Kirchturm, 1920 / Landscape with the Yellow Steeple

18. *Der grosse Kaiser reitet in den Krieg*, 1920 / The Great Emperor Rides to War

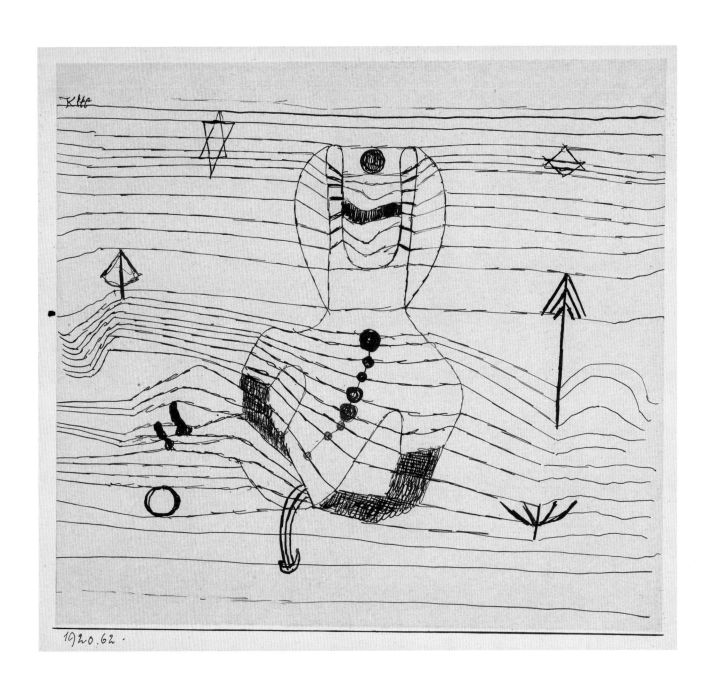

14. *Abgeworfener und verhexter Reiter*, 1920 / Rider Unhorsed and Bewitched

16. *Zeichnung in der Art eines Netzes geknüpft*, 1920 / Drawing Knotted in the Manner of a Net

46. *ARA* *"Kühlung in einem Garten der heissen Zone"*, 1924 / ARA "Cooling in a Garden of the Torrid Zone"

43. *Vorhang*, 1924 / Curtain

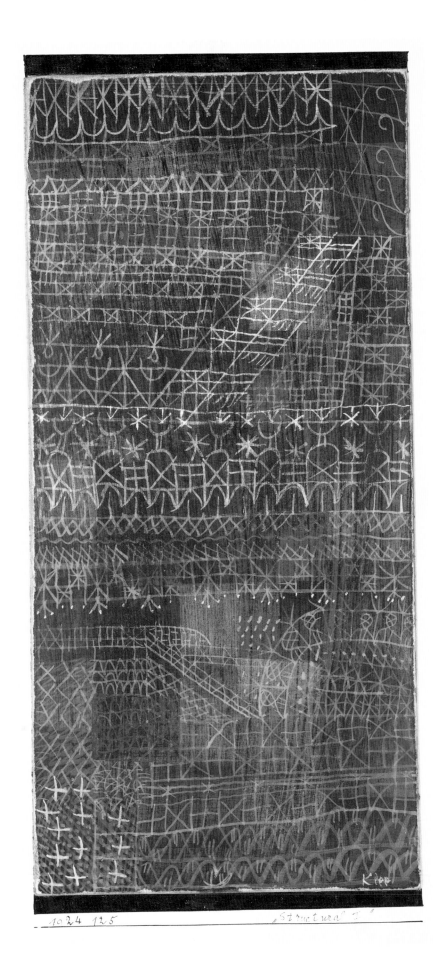

42. *Structural I*, 1924 / Structural I

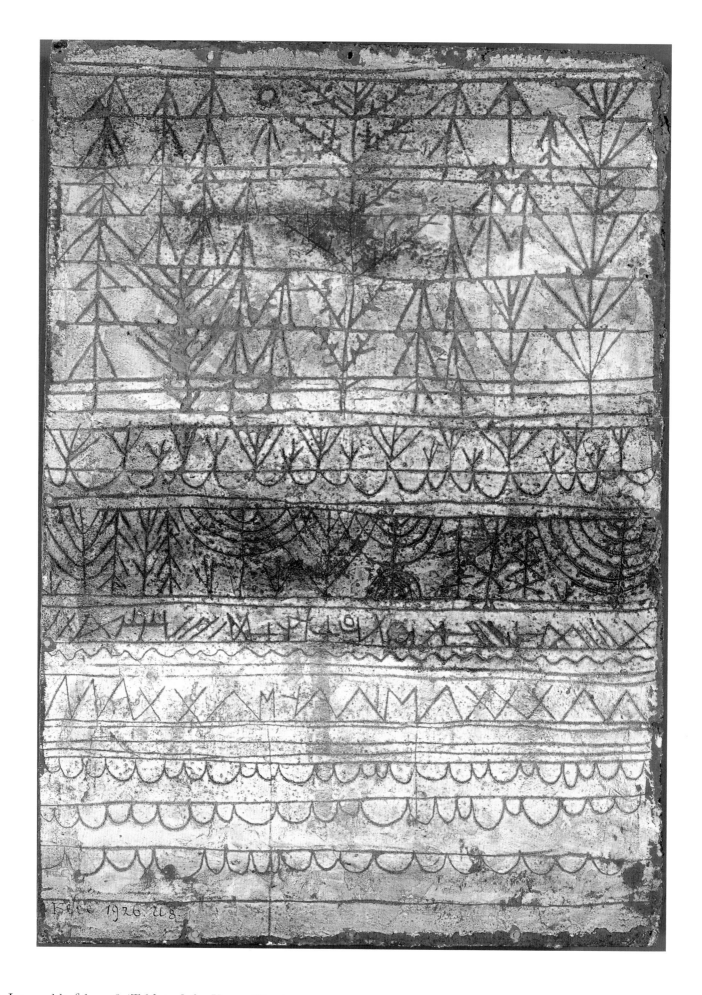

57. *Jungwaldtafel*, 1926 / Tablet of the Young Wood

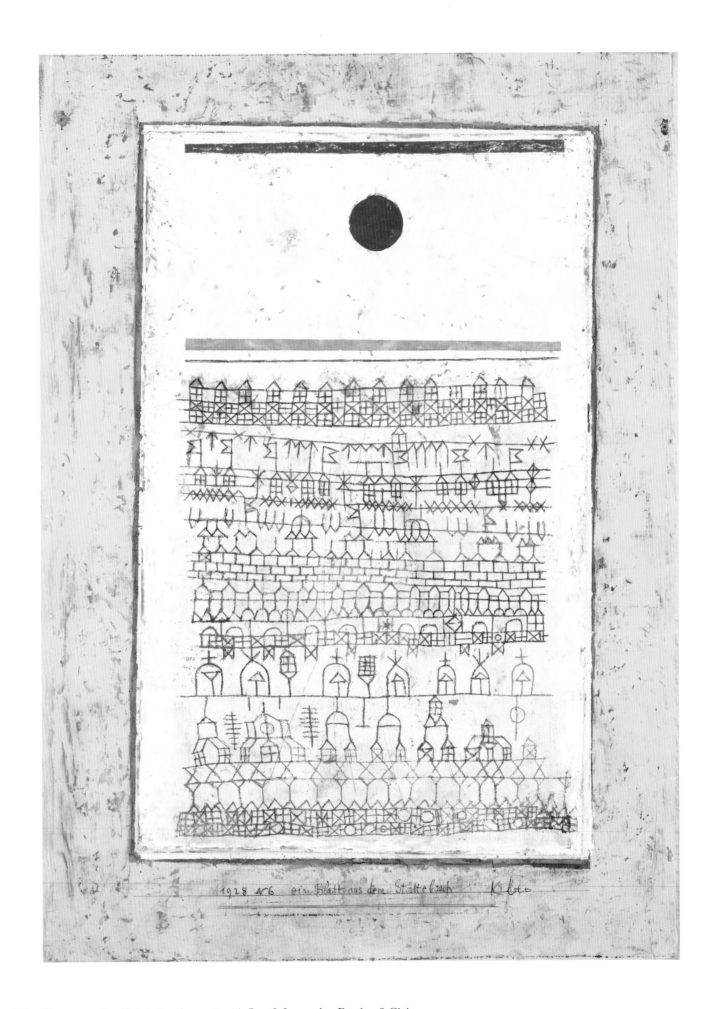

64. *Ein Blatt aus dem Städtebuch*, 1928 / A Leaf from the Book of Cities

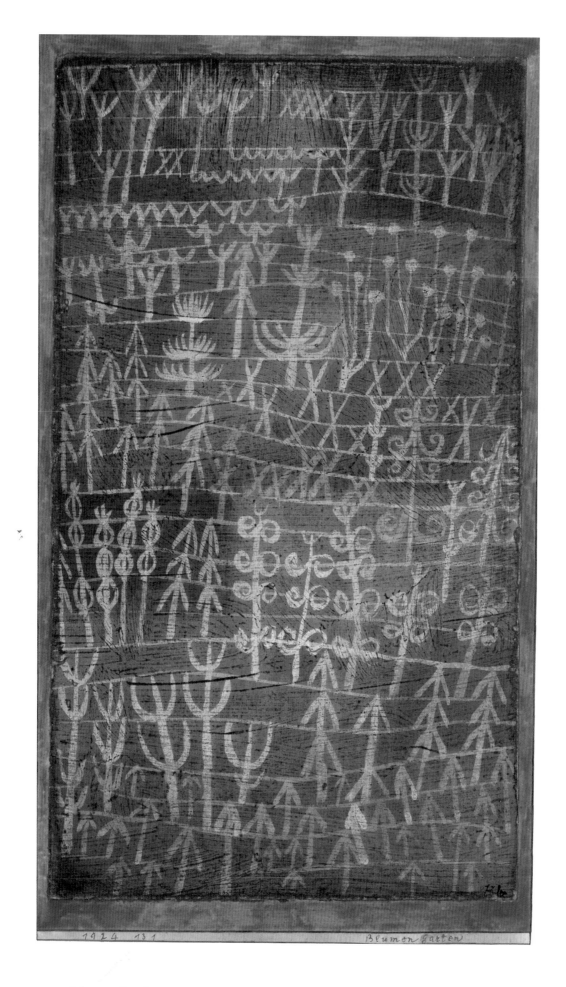

44. *Blumen Garten*, 1924/Flower Garden

47. *Gartenbau*, 1925 / Horticulture

45. *reife Ernte*, 1924 / Ripe Harvest

12. *Rosengarten*, 1920 / Rose Garden

62. *Drohender Schneesturm*, 1927 / Threatening Snowstorm

60. *Segelschiffe, leicht bewegt,* 1927 / Sailing Boats, Gently Moving

1927 224. Härten in Bewegung

61. *Härten in Bewegung*, 1927 / Hardnesses in Motion

The early 1930s were for Klee the most severe test of his theories on art and life. He had accomplished a natural course of development in the evolution of his work, and he had arrived in the international art world. In 1930 the newly founded Museum of Modern Art in New York took his exhibition from the Flechtheim Gallery in Berlin and gave him the first retrospective of a living European artist. But at the same time the world in which he had started out, and in which he had established himself, was being dangerously eroded. By 1929, the working situation at the Bauhaus was overcast by art-political controversies. Walter Gropius, Herbert Bayer, Marcel Breuer and László Moholy-Nagy had left the year before, and Klee himself, exhausted by his teaching, began to look for another post. In 1931 he took up a position at the more conventional Academy of Art in Düsseldorf. But the security of this post did not last long. The organized actions of the Nazis against Modern art had begun in 1930, among them the 'clearing' of the Schlossmuseum Weimar which had ten works by Klee in its collection. The Bauhaus was closed in 1932, and the following year Klee's contract in Düsseldorf was cancelled by the newly appointed director of the Academy.[52]

It was a dramatic chain of events that caught Klee at the height of his powers. On 19 January 1934 he queried in his pocketbook: 'Is Europe limping or is it me?'.[53] Even his return to Switzerland failed to restore stability. In 1935 he contracted measles, which subsequently developed into scleroderma, a very rare and incurable disease in which the skin progressively hardens and which eventually proves fatal. All these factors led to a serious creative crisis, with the result that for the year 1936 the oeuvre catalogue registers the uniquely low output of twenty-five works.

Nevertheless the depth of Klee's understanding of genesis is nowhere shown better than in his artistic response to these disasters. Only Matisse, similarly trapped in the 1940s, reacted in a comparably defiant manner. 'An artist must possess nature', he wrote to Henry Clifford in 1948, and to forestall the obvious misunderstanding added: 'He must identify himself with her rhythm.'[54] That is to say, in any creative life there are not only periods of growth and flowering, but also of denial and withdrawal, and to act in harmony with nature means to accept these fallow periods as an opportunity to return to the roots.

Klee's form of this renewal, which Matisse called 'cultivating the soil', can be seen in his work after 1937, and in the incredible accompanying burst of activity. In 1939, one year before his death, the oeuvre catalogue records a grand, previously unattained, total of 1253 individual pieces.

The most obvious difference in Klee's last body of work is the coarsening of the line, particularly in his paintings. Handicapped by the disease, which increasingly restricted his movements, Klee accepted the fact that the subtle and playful walks he had taken

with the line were no longer possible. But this restriction would have remained an awkward limitation had he not balanced the nature of his work in a new way. With the 'bar-like stroke'[55] came a structure in which disruption and elimination, removal and denial played a role equal to the positive plastic constituents.

This negative aspect of genesis seems to have early on been part of Klee's awareness. In 1912 he wrote a review of an exhibition of contemporary art at the Kunsthaus Zurich, in which he commented on the Cubist dismantling and restructuring of the figure with a certain apprehension. 'Destruction for construction's sake?', he asked, preferring the way in which Delaunay's *Fenêtres* dispensed with natural subject matter altogether.[56] However, in some of his very first oil paintings in 1919 he made an attempt to treat dissolution and the disembodiment of figuration as a creative factor in its own right. *Purple Aster*, 1919 (cat. 9) and *The Thistle Flower House*, 1919 (cat. 8) are part of a group in which the imagery, being reduced to insubstantial ciphers, gives way to a vast, dark, all-embracing space which at the time he equated with the notion of 'cosmos'. He later analysed the plastic principle involved in his pocketbook of 1926-27 as the opposition between 'constructive' and 'restructive' – carefully avoiding the merely negative implications of the word 'destructive'.[57] In Klee's understanding 'constructive' is a physically active, but spatially passive, 'building from within', whereas 'restructive' means the 'decomposition from outside', which is spatially active in opening up pictorial space.

In the work after 1937 this positive aspect of removal and elimination comes increasingly to the fore. The early opposition between individual and dividual elements is replaced by open rhythms in which unconnected individual forms relate through carefully poised and measured intervals. The painting *Secret Letters*, 1937 (cat. 87) is a superb early example of the new dynamism and scale which Klee mastered through articulating interruption instead of literally drawing out movement. And this is not only true of the explicitly rhythmic themes. No one who sees *Niesen Landscape*, 1937 (cat. 90) reproduced for the first time would think that this gouache measures just 35.5 by 27.5 cm – so grand is the space and scale conveyed by a few simple marks and signs.

There is, however, another tendency of working with the positive function of negatives, which is sometimes combined with the fragmented rhythms. The clearly discernible figure in *Pathos II*, 1937 (cat. 89) does not draw its expressive power from expressiveness, as such, but rather from a deliberate suppression of recognizable features. By dismembering the human image and reassembling it according to purely formal echoes, Klee creates a classic 'pathos figure', the persuasion of which lies in its latency. When combined with rhythmic structures, such latent figurations can adopt a physiognomic expression, which is characteristic of much of the late work. In a painting like *The Broken Key*, 1938 (cat. 92) we may objectively recognize nothing but completely abstract elements, and yet we have an undeniable impression that the painting is looking back at us. Such latent physiognomies can become very disquieting, even menacing, as in *Hold*, 1939 (cat. 94), by the very absence of any clue as to what it is that is looking at us. It is the uncertainty that is threatening.

fig. 22
Statement from the
original catalogue *Der
Ararat II*, 'Paul Klee'
Galerie Hans Goltz,
May-June 1920,
Munich, including a
reproduction of
Läufer (Haker-Boxer),
1920
The Runner
(Hooker-Boxer)
watercolour on paper;
21.6 x 30.5 cm
Private Collection,
Germany
Paul-Klee-Stiftung,
Kunstmuseum Bern

This disturbing quality is certainly connected to the fatal perspective of the artist's life. However, it would be wrong and against the inner sense of Klee's art to see in these late works only the traces of mortality. Using the very same means, he created serene paintings, such as *A Children's Game*, 1939 (cat. 93), a homage to the pleasures of a yet unformed life, or diverted our attention to a primal state of formation, as in *The Vase*, 1938 (cat. 91), where the potential of face, vessel or figure is as yet unresolved. Moreover, in the last two years of his life he created a huge body of drawings in which the line, once again thin and supple, gives way to a vast luminous whiteness as the impalpable matrix of formation. These works require a separate study altogether.[58]

Klee's achievement is not about completeness. His late work rounds off with a surprising simplicity and clarity, the position that he had claimed for himself on the occasion of his first retrospective exhibition in 1920 (fig. 22) and which so often has been misunderstood:

> 'I cannot be pinned down here and now,
> because I live as well with the dead
> as with the unborn.
> Somewhat closer to the heart of creation than usual,
> and still not close enough.'[59]

How could this be interpreted as a removal from life? As a withdrawal into an unworldly hinterland? Although this declaration was engraved on his tombstone, it claims the full

range of existence in time. What is gone belongs as much to the present as that which is to come. In Klee's understanding the spirit is 'closer to the heart of creation' when it does not cling to the present, but keeps moving. The gouache *Wandering Artist (A Poster)*, 1940 (cat. 96), cheerfully celebrates the journey between that which has been and that which is not yet. 'Do not define today', he advised his students, 'define backwards and forwards, spatial and many-sided.' His own achievement should be measured accordingly. Because his work never belonged to any one single point in time, it may belong to those 'creations', as Merleau-Ponty put it, which have 'almost all their life before them'.[60]

96. *Wander-Artist (ein Plakat)*, 1940 / Wandering Artist (a Poster)

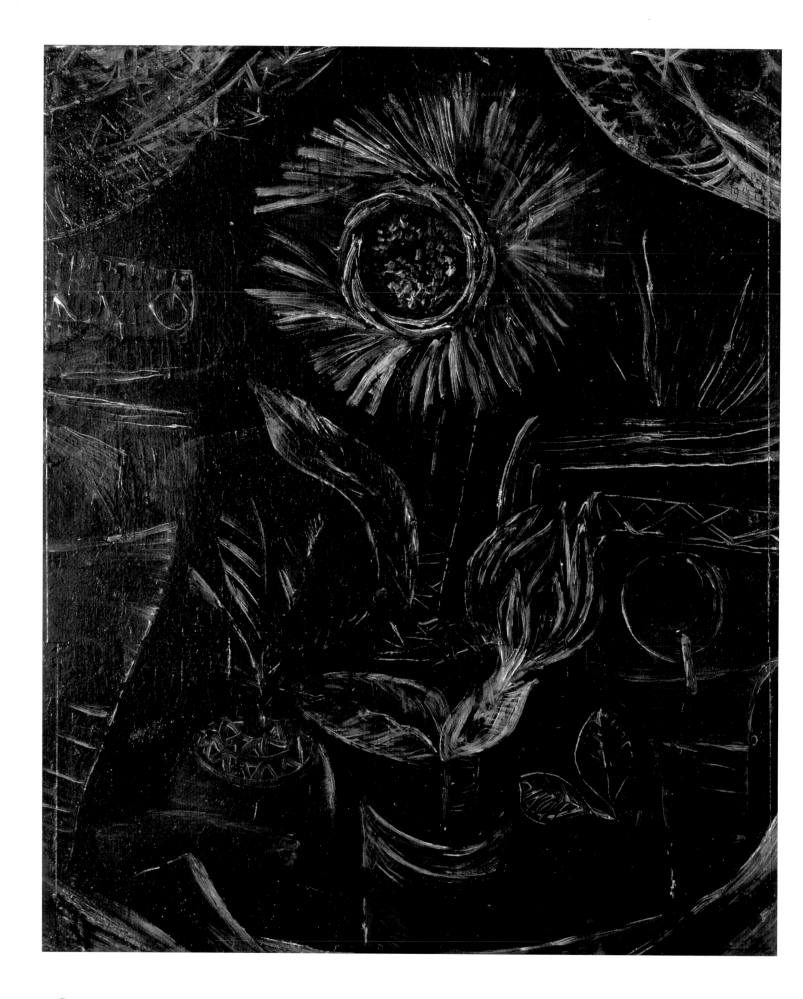

9. *Purpuraster*, 1919 / Purple Aster

8. *Das Haus zur Distelblüte,* 1919 / The Thistle Flower House

87. *Geheime Schriftzeichen*, 1937 / Secret Letters

90. *Niesen-Landschaft*, 1937/Niesen Landscape

88. *Stolz I*, 1937 / Pride I

89. *Pathos II*, 1937

92. *Zerbrochener Schlüssel*, 1938 / The Broken Key

94. *Umgriff*, 1939/Hold

173

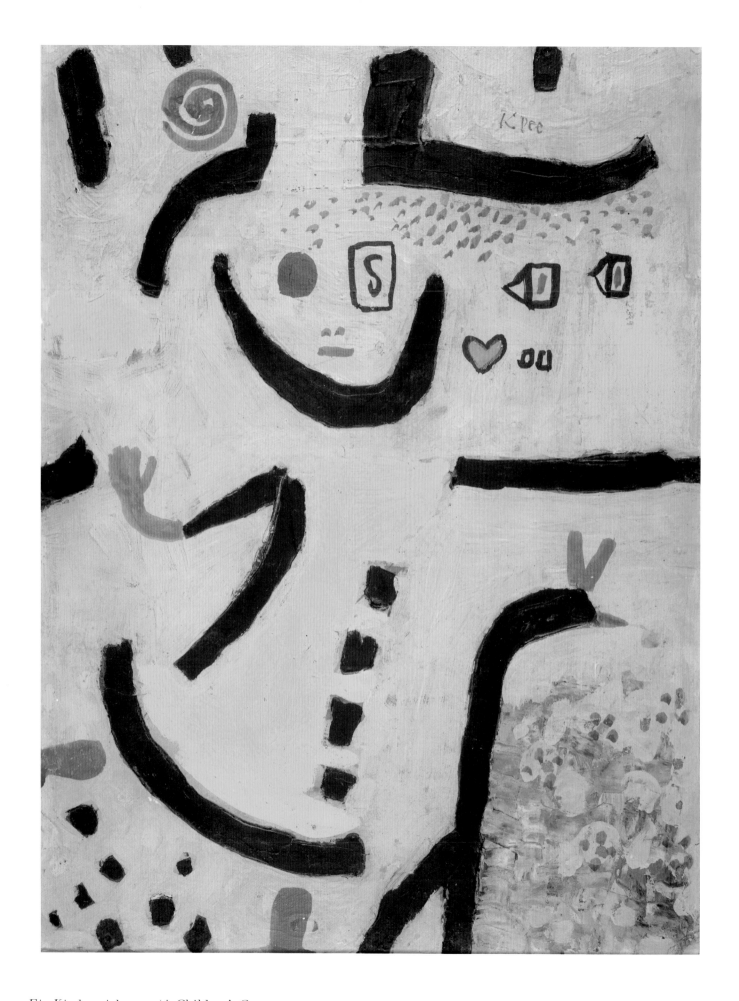

93. *Ein Kinderspiel*, 1939 / A Children's Game

91. *Die Vase*, 1938 / The Vase

95. *Feinarbeit*, 1940 / Fine Work

NOTES

1. Picasso visited Klee on 28 November 1937 in Bern. When, in 1951, he was reminded of this visit, he spontaneously summarized, according to Will Grohmann, his recollection of Klee's presence in this double vision, 'Pascal-Napoleon', meaning a mixture of wisdom and energetic drive. See Will Grohmann, *Paul Klee*, New York, 1954, p. 93.

2. *Collection of the Société Anonyme: Museum of Modern Art 1920*, ed. George Heard Hamilton, New Haven, Connecticut: Yale University Art Gallery, 1950, p. 141.

3. Pierre Boulez, *Le pays fertile: Paul Klee*, ed. Paul Thévenin, Paris, 1989.

4. For a general discussion of Klee's influence during his lifetime see Ann Temkin, 'Klee and the Avant-Garde 1912-1940', in *Paul Klee*, exh. cat., Museum of Modern Art, New York, ed. Carolyn Lanchner, New York, 1987, pp. 13-37.

5. Clement Greenberg, 'The Late Thirties in New York' (1957/1960), in *Art and Culture. Critical Essays*, Boston 1961, p. 232. The special relationship between Klee and the American art scene is the subject of Carolyn Lanchner's contribution 'Klee in America' to the MoMA catalogue, op. cit., pp. 83-111.

6. Clement Greenberg, 'The Present Prospects of American Painting and Sculpture' (1947), in *Clement Greenberg: The Collected Essays and Criticism*, ed. John O'Brian, Chicago-London, 1986-93, vol. 2, 1986, p. 165.

7. Statement from *Der Ararat II* (special edition), 'Paul Klee', Munich: Goltz, 1920, p. 20. Facsimile reprint in Felix Klee (ed.), *The Diaries of Paul Klee*, 1898–1919, London, 1965, p.58

8. Letter to Émile Schuffenecker, 16 October 1888, in *Lettres de Gauguin*, ed. Maurice Malingue, Paris, 1946, p. 147.

9. The *Diaries* were posthumously edited by Felix Klee, *Tagebücher von Paul Klee 1898-1918*, Cologne, 1957 (new edition 1979). Their character as journals was first questioned, and the

artist's editorial work pointed to, by Christian Geelhaar, 'Journal intime oder Autobiographie? Über Paul Klees Tagebücher', in *Paul Klee. Das Frühwerk 1883-1922*, exh. cat., Städtische Galerie im Lenbachhaus München, ed. Armin Zweite, Munich, 1979, pp. 246-60. Subsequently a critical edition was undertaken by the Paul-Klee-Stiftung, Bern: *Paul Klee, Tagebücher 1898-1918*, ed. Wolfgang Kersten, Stuttgart/Teufen, 1988.

10. *Paul Klee – Briefe an die Familie, 1893-1940*, ed. Felix Klee, vol. 1, Cologne, 1979, p. 413 f.

11. The English translation 'I am obsessed with tonality' unnecessarily varies the expression and thereby obscures the deliberate repetition: 'Die Tonalität hat mich' – 'Die Farbe hat mich'.

12. Kandinsky lived at 36, Klee at 32, Ainmillerstrasse. Although Kandinsky was thirteen years older than Klee they both joined Franz von Stuck's class in 1900.

13. From the 'Pedagogical Bequest' (Pädagogischer Nachlass = PN, M1/3), Paul-Klee-Stiftung, Bern. Quoted after Christian Geelhaar, *Paul Klee und das Bauhaus*, Cologne, 1972, p. 48, footnote 31.

14. *Briefe an die Familie*, vol. 1, p. 350 f.

15. The numbers of Klee's own oeuvre catalogue do not automatically reflect the sequence in which the watercolours were made. They were allocated at the end of the year when the artist grouped his work and 'took stock' of his output. See Regula Suter-Raeber, 'Paul Klee: Der Durchbruch zur Farbe und zum abstrakten Bild', in *Paul Klee: Das Frühwerk 1883-1922*, Munich, 1979, pp. 132-33.

16. Cf. the titles of two watercolours 1914-210 and 211, which Klee made after the journey: *In the Kairouan-Style, transposed in a moderate way*. For the later development of the square paintings see Eva-Maria Triska, 'Die Quadratbilder Paul Klees – ein Beispiel für das Verhältnis seiner Theorie zu seinem Werk', in *Paul Klee: Das Werk der Jahre 1919-1933*, exh. cat., Kunsthalle Köln, ed. Siegfried Gohr, Cologne, 1979, pp. 45-72.

17. *Briefe an die Familie*, vol. 1, p. 205.

18. The main sources for this opposition are Friedrich Schiller's essay 'Über naive und sentimentalische Dichtung' (1795/6) and the philosophy of G.W.F. Hegel. In his 'Lectures on Aesthetics' in the 1820s, Hegel based the distinction between Romantic and Classical art on the difference between Christian and Antique culture: the pre-eminence of the expression of an inner world, as opposed to the ideal of physical manifestation. Although not identical, Herbert Read's view of Klee's 'intellectual fairyland' as a 'Gothic world', in contradistinction to the 'Latin imagination', parallels this opposition; cf. *Art Now*, London, 1933, pp. 142 f. The common ground of both generalizations is the dichotomy between an inward and an outward orientation of the spirit.

19. *Briefe an die Familie*, vol. 1, p. 482.

20. Ibid., p. 357.

21. Ibid., p. 507.

22. Quoted after O.K. Werckmeister, *The Making of Paul Klee's Career 1914-1920*, Chicago-London, 1989, p. 172.

23. This important detail has been unearthed by Anita Beloubek-Hammer, 'Paul Klee and Berlin', in *Paul Klee. Späte Werkfolgen*, exh. cat., Kupferstichkabinett Berlin (SMPK), ed. Alexander Dückers, Berlin, 1997, p. 123 f. Paul Klee took part in the first exhibition of the November Gruppe in 1919, in subsequent presentations in 1924, 1929, and finally in the last exhibition of 1931.

24. Letter from Klee to Kandinsky, 18 August 1914. Quoted after Werckmeister, *The Making of Paul Klee's Career*, p. 12, footnote 9 (translation slightly altered by author for this contribution). Werckmeister's presentation and description of the documents – particularly in chapter 1 (1914) and chapter 2 (1915), pp. 12-62 – give an excellent account of this important debate in German art history, clearly distinguishable from the author's historicist, quasi-Marxist interpretation.

25. Letter from Kandinsky to Klee, 10 September 1914, ibid., p. 12, footnote 12.

26. Postcard from Klee to Kubin, 29 December 1914, in *Paul Klee: Das Frühwerk 1883-1922*, exh. cat., Munich, 1979, p. 86.

27. Postcard from Marc to Kandinsky, 16 November 1914, in *Wassily Kandinsky-Franz Marc – Briefwechsel*, ed. Klaus Lankheit, Munich-Zurich, 1983, p. 266 f.

28. Letter from Marc to Kandinsky, 24 October 1914, ibid., p. 263.

29. Franz Marc fell in the Battle of Verdun on 4 March 1916. A few days before he wrote to his wife: 'My focus has *long been turned fully away from the war*. However, my being does not try to attain the indifference of Klee [...] but is only *set right* for once and all, healed and thrown back from the peripheries of earlier interestedness to the deserted centre of *pure function*.' In *Franz Marc, Briefe 1914-1916 aus dem Felde*, 5th edition, Berlin, 1959, pp. 149 f. (The first edition of this collection of letters was banned by the Nazis in 1938.)

30. The development of this theme from a more drastic first version to the refined final solution, in which an 'elegant mixture of greyhound and gazelle' replaces the initial cur, is discussed in Gregor Wedekind, *Paul Klee: Inventionen*, Berlin, 1996, pp. 76 f.

31. Letter from Paul Klee to Paul Éluard, 21 April 1928, quoted in Jürgen Glaesemer, *Handzeichnungen II, 1921-36*, Bern, 1984, p. 94: 'Concerning the drawings and etchings for a publication, I have to say again, that a very long experience warns me against wanting to make something "in addition to". I have once fought for two years such a struggle right to the end (relating to Voltaire's *Candide*). I don't regret these two years because they brought about a fusion. And because one sometimes has to fight.'

32. On Klee's relationship to Surrealism in general see Jürgen Glaesemer, ibid., pp. 93-95. His documentation includes the quotation from Aragon's article in *Littérature*, no. 6, November 1922, which reads in French: 'C'est à Weimar que fleurit une plante qui ressemble à la dent de sorcière'.

33. Klee had his first solo exhibition in Paris with the Galerie Vavin-Raspail from 21 October to 14 November 1925 (thirty-nine watercolours),

which was immediately followed by his inclusion in the exhibition *La Peinture Surréaliste* in the Galerie Pierre, 14 to 25 November (two works). The other artists presented were Arp, de Chirico, Ernst, Masson, Miró, Picasso, Man Ray and Pierre Roy.

34. Alfred Barr Jr, *Paul Klee*, preface to the catalogue of the Klee exhibition at the Museum of Modern Art, New York, 1930, p. 8.

35. Cf. the definition of 'automatisme psychique' in the *Manifest of Surrealism* of 1924: 'Dictée de la pensée, en l'absence de tout contrôle exercé par la raison, en dehors de toute preoccupation esthétique ou morale.' In André Breton, *Oeuvres completes*, ed. Marguerite Bonnet, 3 vols, Paris, 1988, vol. 1, p. 328.

36. Leopold von Zahn, *Paul Klee: Leben/Werk/Geist*, Potsdam, 1920. Wilhelm Hausenstein, *Kairuan oder eine Geschichte vom Maler Klee und von der Kunst dieses Zeitalters*, Munich, 1921.

37. Oskar Schlemmer, *Briefe und Tagebücher*, ed. Tut Schlemmer, Stuttgart, 1977, p. 24.

38. Quoted after O.K. Werckmeister, *The Making of Paul Klee's Career*, footnote 22, p. 217.

39. Karin von Maur, *Oskar Schlemmer*, Munich, 1979, p. 89.

40. The English translation: 'an effort is made to give concrete form to the accidental', distorts the meaning of the original 'Eine Verwesentlichung des Zufälligen wird angestrebt'. The problem is not to give form to something formless, but to show the present state as a relative, 'accidental' moment within a bigger range of possibilities, past and future.

41. Henri Matisse, *Écrits et propos sur l'art*, ed. Dominique Fourcade, Paris, 1972. Cf. 'Notes d'un peintre' (1908) and, in particular, 'Propos rapportés par Tériade' (1936): 'C'est le point de départ du Fauvisme: le courage de retrouver la pureté des moyens' (p. 128).

42. Maurice Merleau-Ponty, *L'Oeil et l'esprit*, Paris, 1964.

43. J.W. Goethe, 'Über die Spiraltendenz der Vegetation' (*c.* 1930), in *Goethes Werke*, in 14 vols (Hamburg Edition), ed. Erich Trunz, Munich, 1981, vol. 13, pp. 130-48.

44. Cf. Klee's explanations in TE, p. 488 following, and Osamu Okuda's contribution 'Tonality and Colour' in *Paul Klee: Die Kunst des Sichtbarmachens. Materialien zu Klee's Unterricht am Bauhaus*, Bern, 2000, p. 32 following.

45. Letter from Klee to Dr Ernst Latzko, 12 February 1926, quoted in Christian Geelhaar, *Paul Klee und das Bauhaus*, Cologne, 1972, pp. 82 f. Both Will Grohmann and Felix Klee recall that the artist knew the score of *Don Giovanni* by heart.

46. Letter to Lily, 3 December 1921, in *Briefe an die Familie*, vol. 2, p. 983.

47. The philosophical poetics of German Romanticism can be found in the 'Fragments and Studies 1797-1798' of Novalis (alias Friedrich von Hardenberg, 1772-1801): 'The world has to be romanticized. In this way one discovers the original sense [...] This operation is still completely unknown. By endowing the commonplace with a high significance, the plain with a mysterious aura, by attributing the dignity of the unknown to the well known and an air of infinity to the finite, I romanticize it. The reverse procedure must be applied to the lofty, unknown, mystical, infinite ... Mutual lifting and degrading.' In *Novalis Werke*, ed. Gerhard Schulz, Munich, 1969, pp. 384 ff [translated by author for the purposes of this contribution]. Since Joseph Beuys picked up on these aesthetics, the operation has become fairly well known (see Theodora Vischer, *Beuys und die Romantik*, Cologne, 1983). The rather tenuous connection between Beuys and Klee is the subject of *Paul Klee trifft Beuys: Ein Fetzen Gemeinsamkeit*, exh. cat., Museum Schloss Moyland, ed. Tilman Osterwold, Stuttgart, 2000.

48. *Paul Klee. Im Zeichen der Teilung*, exh. cat., Kunstsammlung Nordrhein-Westfalen Düsseldorf and Staatsgalerie Stuttgart, ed. Wolfgang Kersten and Osamu Okuda, Stuttgart, 1995. This catalogue registers ninety-five examples of this separation process. Meanwhile, more than a hundred works have been found, see Christian Rümelin, 'Klee's Interaction with his Own Oeuvre', in *Paul Klee. Selected by Genius 1917-1933*, ed. R. Doschka, Munich-London-New York, 2001, p. 30 f., footnote 81.

49. Two obvious examples are discussed in *Constantin Brancusi, 1876-1957*, exh. cat., Musée national de l'art moderne, Centre Georges Pompidou, Paris, 1995: the extraction of *Tête d'enfant*, 1914/15, from *Le Premier Pas*, 1914, pp. 128 f. (Margit Rowell); and the relationship of *Socrate*, 1921/22 , to the abandoned combinations *Socrate et Platon*, 1922, and *Socrate et Coupe*, 1922, pp. 186 f. (Ann Temkin).

50. A student of Klee's recalled that he drew special attention to the borders of the pictorial field: 'I warn you of the edge, the thing should not touch. Think of a basin with water, which may overflow.' In Petra Petitpierre, *Aus der Malklasse von Paul Klee*, Bern, 1957, p. 29.

51. Klee's reviews of music performances for the *Berner Fremdenblatt & Verkehrszeitung* in the years 1903-06 are collected in *Paul Klee, Schriften, Rezensionen, Aufsätze*, ed. Christian Geelhaar, Cologne, 1976, pp. 36-92.

52. See the chapter '1933-1945: Deutschland – Offizielle Verfolgung und versuchte Weiter führung' in Christine Hopfengart, *Klee. Vom Sonderfall zum Publikumsliebling. Stationen seiner öffentlichen Resonanz in Deutschland 1905-1960*, Mainz, 1998, pp. 97-112.

53. *Briefe an die Familie*, vol. 2, p. 1242.

54. *Matisse on Art*, ed. Jack D. Flam, London, 1973, p. 121.

55. Will Grohmann, *Paul Klee*, New York, 1954, pp. 326 ff.

56. *Schriften, Rezensionen, Aufsätze*, Cologne, 1976, p. 107-08.

57. *Briefe an die Familie*, vol. 2, p. 1030.

58. Gottfried Boehm, 'Strebend nach Gesicht' – Hinweise zum zeichnerischen Spätwerk Paul Klees', in *Paul Klee. Späte Zeichnungen von 1939*, exh. cat., Museum Folkwang Essen and Museum Fridericianum Kassel, 1989, pp. 157-64.

59. See note 7.

60. Maurice Merleau-Ponty, *L'Oeil et l'esprit*, Paris, 1964, p. 93.

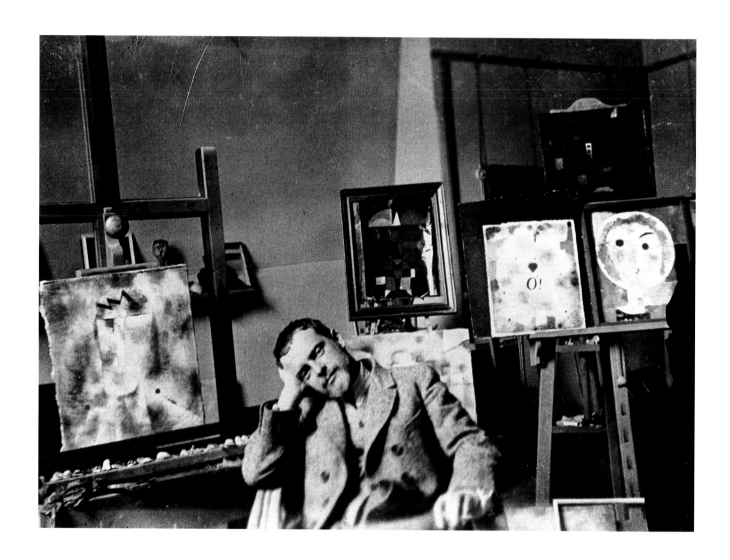

fig. 23
Paul Klee in his studio,
Weimar, 1922
Klee Family Estate
Deposited at the Paul-Klee-Stiftung,
Kunst-museum Bern
Photo: Felix Klee

CHRONOLOGY

This abridged chronology is based on the extended account by Sabine Rewald, *Paul Klee. The Berggruen Klee Collection in the Metropolitan Museum of Art*, New York, 1988, pp. 290-301.

1879
Paul Klee is born on 28 December in Münchenbuchsee, a suburb of Bern, Switzerland. Second child of Hans Klee (1849-1940), a German music teacher, and his Swiss wife Ida Marie Klee (née Frick, 1855-1921). Shows early gift for music and an interest in drawing.

1886-98
Regular schooling, graduates in 1898 from the Literarschule Bern, where he develops an interest in Ancient Greek and French literature which is to last all of his life. Parallel to his formal education, takes violin lessons from Karl Jahn, a former pupil of the celebrated violinist Joseph Joachim. His talent and skill secure him a place in the orchestra of the Bernese Music Society. He is undecided for a long time between music and visual art, but he finally chooses art and moves to Munich in October 1898.

1898-1901
Enters the private drawing school of the academic painter Heinrich Knirr, in preparation for the Academy. Attends concerts and operas frequently. At a musical soirée in December 1899, he meets his future wife, the pianist Lily Stumpf (1876-1946). In autumn 1900, he enrols in the class of Franz von Stuck at the Academy. Although Wassily Kandinsky is a fellow student, they do not become acquainted.

1901-02
Concludes his studies in Munich and becomes engaged secretly to Lily Stumpf before returning to Bern at the end of June. In October he starts a six-month tour of Italy with the sculptor Hermann Haller, a childhood friend. They visit Milan, Genoa, Pisa, Rome, Naples and Florence. Overwhelmed by the art of the Renaissance and Antique art he is haunted by the fear of living in an epigonic age and sees his future in 'caricatures'. In May 1902, returns to Bern where he is to remain until 1906.

1902-06
Period of relative seclusion devoted to his 'self-education'. Regular visits to and from Lily Stumpf, who lives in Munich. He is employed by the Bernese Music Society for two concert seasons as a violinist. From October 1903 until March 1906 he reviews opera and concerts for the *Berner Fremdenblatt & Verkehrszeitung*, published by his friend Hans Bloesch.

1903
Begins the series of etchings called *Inventions* (completed in 1905), which he describes as Opus One, his 'critique of the bourgeoisie'.

1904

During a ten-day visit to Munich in October, Klee studies the works of Goya, William Blake and Aubrey Beardsley in the Kupferstichkabinett.

1905

At the beginning of June, first visit to Paris, accompanied by Hans Bloesch and the painter Louis Moilliet. Spends many hours in the Louvre and the Musée du Luxembourg; however, there is no mention of contemporary French painting in his diary.

1906

In April, travels to Berlin to see the centennial exhibition of German art (1775 to 1885). Ten etchings from his *Inventions* series are shown in the Munich Secession exhibition. In September, he marries Lily Stumpf in Bern and moves to Munich.

1907-10

After the birth of their only child, Felix, he takes care of the household while Lily earns money by giving piano lessons. The summers are usually spent in Bern. In spring 1908, Klee sees the exhibitions of Van Gogh in two private galleries in Munich. The following year he encounters the work of Cézanne who is represented by eight paintings in the Munich Secession exhibition. In August 1910, Klee's first solo exhibition, of more than fifty works from the period 1907-1910, opens at the Kunstmuseum Bern. The exhibition travels to Zurich, Wintherthur and the Kunsthalle Basel (January 1911).

1911-14

Klee makes contact with the contemporary art scene. In February 1911, he begins a work catalogue of his past and current paintings, including some that date back to 893.

1911

In January, Alfred Kubin pays a visit to Klee in Bern marking the beginning of a life-long friendship. Klee starts work on a series of illustrations for Voltaire's *Candide*. Through his friend, Louis Moilliet, he meets the painter August Macke and makes the acquaintance of Kandinsky. Contributes reviews of art exhibitions and opera performances to the Swiss monthly magazine *Die Alpen* (until December 1912).

1912

Klee joins the Blue Rider group, founded by Kandinsky and Franz Marc, and exhibits seventeen of his works in their second exhibition in Munich. At the beginning of April he spends two weeks with his wife and a Swiss painter friend in Paris. He visits Robert Delaunay in his studio, and encounters the work of Picasso, Braque, Derain, de Vlaminck and Matisse. Enters into a close friendship with Marc, who introduces him to Herwarth Walden, the founder of the magazine and gallery Der Sturm in Berlin.

1913

Über das Licht, Klee's free translation of Delaunay's essay *La Lumière*, 1912 appears in the January issue of *Der Sturm*. Herwarth Walden shows Klee's work in Berlin.

1914

In April, embarks with Macke and Moilliet on a journey to Tunisia that has a decisive effect on his artistic self-confidence: 'Colour and I are one. I am a painter'. Exhibits eight of the Tunisian watercolours in the first exhibition of the New Munich Secession, of which he is a founding member, acting as its secretary from 1918 to 1920.

1914-18

The outbreak of the First World War on 1 August 1914 finds Klee in Bern. The Blue Rider group is dispersed. Kandinsky, Gabriele Münter, Marianne von Werefkin and Alexej von Jawlensky all leave Germany. Macke dies in the first weeks of the war, Marc in March 1916, only a few days before Klee is drafted. He does not have to serve in action, but is assigned to tasks behind the front. The intellectual confusion surrounding the war leads Klee to a more distant view of the Romantic heritage: 'Cool Romanticism'. Draws and paints during his spare time. In November 1918 he finishes an essay that appears in 1920 in an anthology of artists' writings titled *Schöpferische Konfession* (the so-called 'Creative Credo').

1919

In the aftermath of the November 18 Revolution, Klee joins radical organizations of artists and becomes a member of the commissariat for painting in Bavaria's short-lived 'Soviet Republic' (Räterepublik), proclaimed in April 1919. When this regime is ousted through military intervention at the beginning of May, Klee flees to Switzerland. In November, the Stuttgart Academy of Art rejects the proposal of the Student's Council, represented by Oskar Schlemmer, to appoint Klee as a professor.

1920

Klee's Munich dealer, Hans Goltz, shows a large retrospective exhibition with 362 of his works. In autumn, the first monograph on Klee, written by Leopold von Zahn, appears. On 29 October, he receives a telegram from Walter Gropius offering him a position at the Bauhaus, the new State School of Art and Design in Weimar.

1921-31

The Bauhaus period. Klee starts teaching in January 1921. Among his colleagues, besides Gropius, are Feininger, Schlemmer, Itten, Muche, Adolf Meyer, and Marcks; Kandinsky joins the staff the following year. His assignments over the years are very varied, covering all areas of the arts and crafts: 'form master' (artistic advisor) in the bookbinding and stained-glass workshops, basic instruction, courses on textile composition and theory of form as well as painting and sculpture classes. When the Bauhaus, owing to political pressure, moves from Weimar to Dessau in 1925, Klee follows and, from 1926 onwards, the Klees share with the Kandinskys one of the new houses for the professors built by Gropius. The summers are often spent travelling abroad, particularly in Italy and France.

1921

With the beginning of the winter semester, Klee starts a series of lectures titled 'Contributions to the theory of plastic forms' (Beiträge zur bildnerischen Formenlehre), published in 1979 by the Paul Klee Foundation, Bern.

1923

Klee's essay 'Ways of Nature Study' (Wege des Naturstudiums) appears in the publication accompanying the summer exhibition *Staatliches Bauhaus - Weimar 1919-23*. In October he exhibits at the Nationalgalerie im Kronprinzenpalais, Berlin.

1924

First solo exhibition in the United States at the Société Anonyme, New York. On the occasion of his exhibition at the Kunstverein in Jena, Klee delivers the famous lecture which is published postumously in 1945 as 'On Modern Art' (Über die moderne Kunst).

1925

Klee's 'Pedagogical Sketchbook' (*Pädagogisches Skizzenbuch*) appears as volume 2 in the series of Bauhaus books edited by Gropius and Moholy-Nagy. First solo exhibition in France at the Galerie Vavin-Raspail, Paris. Participates with two works in the first group exhibition of the Surrealists at the Galerie Pierre, Paris.

1928

In March, Gropius, Bayer, Breuer, and Moholy-Nagy leave the Bauhaus. Under the new directorship of Hannes Meyer, the curriculum becomes more strictly regulated and orientated towards architecture. Klee's essay 'Exact Investigations in the Realm of Art' (Exakte Versuche im Bereich der bildenden Kunst), which appears in the 3 February issue of the *Bauhaus* magazine, can be seen as a reaction to this change of policy. In the winter 1928-29, Klee makes a journey to Egypt that inspires an important group of works, such as *Main Way and Byways*, 1929.

1929

First discussions about a teaching post at the Düsseldorf Academy. Klee's fiftieth birthday is celebrated by exhibitions in Dresden, Paris and Berlin. Will Grohmann's first monograph on Klee is published by *Cahiers d'Art* in Paris.

1930

Klee's main dealer since 1928, Alfred Flechtheim, organizes a large solo exhibition in his Berlin gallery, which is subsequently shown at The Museum of Modern Art, New York. Klee informs the Bauhaus of his intention to leave at the end of the winter semester.

1931-33

In October 1931, joins the faculty of the Düsseldorf Academy as professor of painting. Meanwhile the organized actions of the Nazis against Modern art have begun. The Bauhaus in Dessau is closed in autumn 1932; its re-opening in Berlin lasts only until

April the following year. In March 1933, Klee's house in Dessau is searched during his absence. On 6 April, Klee is removed from the list of teachers: 'Prof. Klee as Jew [sic] and teacher impossible and dispensable' and is dismissed two weeks later. At the end of December he leaves with his family for Switzerland.

1934-40
Klee's last years in Bern. Despite the loyalty of a few collectors and contracts with Kahnweiler in Paris (1933) and Nierendorf in New York (1938) this is a difficult period. In addition to the deteriorating political situation, Klee's life is upset by a severe illness. He contracts measles and subsequently develops symptoms that are diagnosed in 1936 as scleroderma, an incurable disease.

1934
First exhibition in England, at the Mayor Gallery, London. Kahnweiler shows Klee's work in his gallery in Paris that is now called Galerie Simon.

1935
Will Grohmann's book on Klee's drawings of the years 1921-30 appears and, during its distribution in Germany, is confiscated by the Nazis. Exhibitions in Bern, Basel and Luzern.

1936
Klee's own catalogue of his oeuvre registers only twenty-five works for this year.

1937
On the occasion of an exhibition in Bern, Kandinsky visits Klee. Seventeen works of Klee are included in the exhibition 'Degenerate Art' (*Entartete Kunst*) in Munich, and over one hundred are confiscated from public collections in Germany. In November Picasso visits Klee in Bern.

1939
Klee, by birth a German citizen, applies a second time for Swiss citizenship, having been rejected earlier on formal grounds. He produces 1253 works, most of them drawings.

1940
The Kunsthaus Zurich opens an exhibition of works made between 1933 and 1940 in honour of Klee's sixtieth birthday the year before. On 29 June 1940, Paul Klee dies in the hospital Sant'Agnese in Muralto-Locarno.

SELECT BIBLIOGRAPHY

Writings by Paul Klee

Christian Geelhaar (ed.), *Paul Klee. Schriften, Rezensionen, Aufsätze*, Cologne, 1976.

Jürgen Glaesemer (ed.), *Paul Klee: Beiträge zur bildnerischen Formlehre*. Facsimile edition of the manuscript of Klee's first series of lectures in the winter semester 1921-22 at the Bauhaus in Weimar, Basel-Stuttgart, 1979 (new edition: Basel, 1999).

Felix Klee (ed.), *Paul Klee. Tagebücher 1898-1918*, Cologne, 1957. English edition authorized by Felix Klee: *The Diaries of Paul Klee, 1898-1918*, London, 1965.

Felix Klee (ed.), *Paul Klee. Briefe an die Familie 1893-1940*, 2 ols., Cologne, 1979.

Paul Klee, *Pädagogisches Skizzenbuch*, Munich, 1925 (= Bauhausbücher 2). English edition: *Pedagogical Sketchbook*, transl. by Sybil Moholy-Nagy, New York, 1953 (new edition: London, 1984).

Paul Klee, *Über die moderne Kunst*, Vortrag im Kunstverein Jena, 1924, postumously published by Hans Meyer-Benteli, Bern, 1945. English edition: *On Modern Art*, transl. by Paul Findlay, introd. by Herbert Read, London, 1948. First critical edition in German: *Paul Klee in Jena 1924*, exh. cat. of the Stadtmuseum Göhre, Jena, 2 vols. (Die Ausstellung/Der Vortrag), Jena, 1999 (= Minerva. Jenaer Schriften zur Kunstgeschichte, vol. 10).

Paul Klee. Tagebücher 1898-1918, critical edition by the Paul Klee Stiftung, Bern, ed. Wolfgang Kersten, Stuttgart-Teufen, 1988.

Jürg Spiller (ed.), *Paul Klee. Das bildnerische Denken, Schriften zur Form- und Gestaltungslehre*, Teil 1, Basel-Stuttgart, 1956. English edition: *The Thinking Eye, The Notebooks of Paul Klee*, transl. by Ralph Mannheim, Charlotte Weidler and Joyce Wittenborn, London-New York, 1961.

Jürg Spiller (ed.), *Paul Klee. Unendliche Naturgeschichte, Schriften zur Form und Gestaltungslehre*, Teil 2, Basel-Stuttgart, 1970. English edition: *The Nature of Nature, The Notebooks of Paul Klee*, vol. 2, transl. by Heinz Norden, London-New York, 1973.

Harriet Watts (ed.), *Three Painter Poets: Arp, Schwitters, Klee. Selected Poems*, Harmondsworth, 1974.

Selected Catalogues and Books on Klee

A comprehensive account of the Klee literature and exhibitions since 1900 can be found in the 'Appendices' of each volume of *Paul Klee. Catalogue raisonné*, ed. by the Paul Klee Stiftung, 9 vols., Bern, 1998 ff. To date, four volumes have appeared. The last one, vol. 4 (1923-1926), updates the bibliography to the year 2000. The following selection is restricted to the last twenty years and, except for a few exceptions, focuses on English publications.

Michael Baumgartner (ed.), *Paul Klee: Die Kunst des Sichtbarmachens. Materialien zu Klees Unterricht am Bauhaus*, exh. cat. (with contributions by Susanne Friedli, Thomas Kain, Osamu Okuda, Rossella Savelli and the editor), Paul Klee Stiftung, Bern, 2000.

Pierre Boulez, *Les pays fertile. Paul Klee*, ed. Paul Thévenin, Paris, 1989.

Richard Calvocoressi, 'Klee's reception in Scotland and England 1930-1945' in: *Paul Klee. Die Sammlung Bürgi*, exh. cat., Kunstmuseum Bern, Kunsthalle Hamburg and Scottish National Gallery of Modern Art, Edinburgh, 2000, pp. 229-45.

Marcel Franciscono, *Paul Klee. His Work and Thought*, Chicago-London, 1991.

Ernst-Gerhard Güse, *Die Tunisreise: Klee, Macke, Moilliet*, Stuttgart, 1982.

Charles W. Haxthausen, *Paul Klee: The Formative Years*, New York-London, 1981 (revised reprint of the dissertation of 1976).

Jim M. Jordan, *Paul Klee and Cubism*, Princeton, 1984.

Andrew Kagan, *Paul Klee. Art & Music*, Ithaca-London, 1983.

Wolfgang Kersten, Osamu Okuda (eds.), *Paul Klee. Im Zeichen der Teilung*, exh. cat. Kunstsammlung Nordrhein-Westfalen and Staatsgalerie Stuttgart, Stuttgart, 1995.

Klee et la musique, exh. cat. (with contributions by Marcel Franciscono, Jürgen Glaesemer and Walter Salmen), Henie-Onstad Kunstsenter, Hovikodden, and Musée national d'art moderne, Centre Georges Pompidou, Paris, 1985.

Paul Klee, exh. cat., Museum of Modern Art New York, ed. Carolyn Lanchner (with contributions by Josef Helfenstein, Jürgen Glaesemer, O.K. Werckmeister, Ann Temkin and the editor), New York, 1987.

Paul Klee. Das Schaffen im Todesjahr, exh. cat. (with contributions by Marcel Franciscono, Ernst-Gerhard Güse, Charles W. Haxthausen, Josef Helfenstein), Kunstmuseum Bern, 1990.

Sabine Rewald (ed.), *Paul Klee, The Berggruen Collection in The Metropolitan Museum of Art*, New York, 1988.

Richard Verdi, *Klee and Nature*, London, 1984.

O.K. Werckmeister, *The Making of Paul Klee's Career 1914-20*, Chicago-London, 1989.

LIST OF WORKS

All measurements are height by width. In the reproductions of paintings, measurements indicate the outer limits of the painted surface. For watercolours, colour prints, and drawings, they indicate the size of the work, excluding the mount.

Klee kept meticulous records of his output for much of his life. From 1911 he maintained a hand-written catalogue listing each work with a serial number, title and brief particulars. Works as they appear here have been listed according to this numerical ordering, represented by a number after the year in which the work was made, which is listed at the end of each entry. From 1925 certain works have an additional categorization of letters and roman numerals. While this identification reflects the order in which the artist inscribed the works, it does not reflect a strict chronology of production in that year.

English translations of Klee's titles for works dated up to and including 1926 are as they appear in the first four voumes of *Paul Klee, Catalogue Resumé*, published by the Paul-Klee Stiftung, Bern.

1 (p. 115)
Pädagogischer Nachlass (Kegelschnitte)
Schichtung genetisch angewendet, undated
Pedagogical Writings (Conic Sections)
Stratification Applied Genetically
purple crayon and pencil on paper
33 x 21 cm
PN 15 M16/148
Paul-Klee-Stiftung, Kunstmuseum Bern
Photo: Peter Lauri, Bern

2 (p. 125)
Pädagogischer Nachlass (Planimetrische Gestaltung)
Natürliches Wachstum und progressive Lagenfolge, undated
Pedagogical Writings (Planimetrical Creation)
Natural Growth and Progressive Layer Sequence
red and green crayon and pencil on paper
33 x 21 cm
PN 16 M17/117
Paul-Klee-Stiftung, Kunstmuseum Bern
Photo: Peter Lauri, Bern

3 (p. 124)
Pädagogischer Nachlass (Planimetrische Gestaltung)
Wachstum und Verzweigung, undated
Pedagogical Writings (Planimetrical Creation)
Growth and Ramification
red and green crayon and pencil on paper
33 x 21 cm
PN 16, M17/118a
Paul-Klee-Stiftung, Kunstmuseum Bern
Photo: Peter Lauri, Bern

4 (p. 36)
Abstraction eines Motives aus Hammamet, 1914
Abstraction of a Motif from Hammamet
watercolour and pencil on paper mounted on card
12.5 x 9.6 cm
1914-49
Private Collection

5 (p. 39)
Rote und weiße Kuppeln, 1914
Red and White Domes
watercolour and gouache on paper
mounted on card
14.6 x 13.7 cm
1914-45
Kunstsammlung Nordrhein-Westfalen,
Düsseldorf
Photo: Walter Klein, Düsseldorf

6 (p. 37)
Aquarell, 1914
Watercolour
watercolour on paper mounted on
cardboard
10.2 x 11.1 cm
1914-94
The Metropolitan Museum of Art, The
Berggruen Klee Collection, 1984

7 (p. 38)
Hommage à Picasso, 1914
Homage to Picasso
oil on cardboard
38 x 30 cm
1914-192
Private Collection

8 (p. 167)
Das Haus zur Distelblüte, 1919
The Thistle Flower House
oil on cardboard
34.5 x 29.5 cm
1919-175
Städtische Galerie im Städelschen
Kunstinstitut, Frankfurt am Main
Photo: Blauel/Gnamm - Artothek

9 (p. 166)
Purpuraster, 1919
Purple Aster
oil on paper mounted on card
34 x 29 cm
1919-179
museum kunst palast, Düsseldorf

10 (p. 57)
Sie beissen an, 1920
They're Biting
oil transfer drawing and watercolour on
paper mounted on card
31.1 x 23.5 cm
1920-6
Tate. Purchased 1946
Photo © Tate, London 2001

11 (p 60)
Schleiertanz, 1920
Veil Dance
oil transfer drawing and watercolour on
paper mounted on card
25.9 x 40 cm
1920-34
Israel Museum Collection, Jerusalem
Photo © The Israel Museum, Jerusalem
not in exhibition

12 (p. 153)
Rosengarten, 1920
Rose Garden
oil and pen on paper on carton
49 x 42.5 cm
1920-44
Städtische Galerie im Lenbachhaus,
Munich
Photo © Städtische Galerie im
Lenbachhaus München

13 (p. 62)
Industrielle Landschaft, 1920
Industrial Landscape
pencil on paper mounted on card
12.5 x 28.5 cm
1920-58
Kunstsammlung Nordrhein-Westfalen,
Düsseldorf
Photo: Walter Klein, Düsseldorf

14 (p. 141)
Abgeworfener und verhexter Reiter, 1920
Rider Unhorsed and Bewitched
pen and ink on wove paper mounted
on cardboard
19.4 x 21.3 cm
1920-62
The Metropolitan Museum of Art, The
Berggruen Klee Collection, 1984

15 (p. 58)
Vogel-Drama, 1920
Bird Drama
pen on paper mounted on card
18.7 x 28.2 cm
1920-93
Private Collection Switzerland

16 (p. 142)
*Zeichnung in der Art eines Netzes
geknüpft*, 1920
Drawing Knotted in the Manner
of a Net
pen and ink on wove paper mounted on
cardboard
31.1 x 19.1 cm
1920-98
The Metropolitan Museum of Art,
The Berggruen Klee Collection, 1984

17 (p. 139)
*Landschaft mit dem gelben
Kirchturm*, 1920
Landscape with the Yellow Steeple
oil and pen on cardboard
48.5 x 54 cm
1920-122
Bayerische Staatsgemäldesammlungen,
Staatsgalerie moderner Kunst

18 (p. 140)
Der grosse Kaiser reitet in den Krieg, 1920
The Great Emperor Rides to War
oil transfer drawing and watercolour on
paper mounted on card
31 x 23.8 cm
1920-173

Staatliche Museen zu Berlin.
Nationalgalerie. Sammlung Berggruen
Photo: Jens Ziehe
Photo © bpk, Berlin

19 (p. 63)
Birnen-Destillation, 1921
Distillation of Pears
oil-transfer drawing, pen and watercolour
on paper, bordered with watercolour and
pen, mounted on card
25.7 x 36 cm
1921-10
Bayerische Staatsgemäldesammlungen,
Leihgabe aus Privatbesitz
Photo: Bayer & Mitko - Artothek

20 (p. 61)
Stadt im Zwischenreich, 1921
City in the Intermediate Realm
oil transfer drawing and watercolour
on paper mounted on card
31.3 x 48 cm
1921-25
Columbus Museum of Art, Ohio
Gift of Howard D. and Babette L.
Sirak, the Donors to the Campaign for
Enduring Excellence, and the
Derby Fund
not in exhibition

21 (p. 87)
Zimmer Perspektive rot/grün, 1921
Room Perspective Red/Green
watercolour, ink and pencil on wove
paper mounted over India ink on paper
strips, mounted on card
20 x 26.4 cm
1921-46
Norton Simon Museum, Pasadena, CA,
The Blue Four Galka Scheyer Collection,
1953

22 (p. 59)
Die Equilibristin über dem Sumpf, 1921
She-Equilibrist Over the Swamp
pen on paper mounted on card
29.5 x 18 cm
1921-59
Kunstsammlung Nordrhein-Westfalen,
Düsseldorf
Photo: Walter Klein, Düsseldorf

23 (p. 111)
Trocken-Kühler Garten, 1921
Dry-Cool Garden
watercolour on paper bordered with
silver paper, mounted on card
24.1 x 30.5 cm
1921-83
Öffentliche Kunstsammlung Basel,
Kupferstichkabinett, Estate of Richard
Doetsch-Benziger, Inv. 1960.57
Photo: Martin Bühler

24 (p. 98)
Kristall-Stufung, 1921
Crystal Gradation
watercolour on paper with pen and ink
marginal stripes, mounted on card
24 x 31.3 cm
1921-88
Öffentliche Kunstsammlung Basel,
Kupferstichkabinett, Endowment
Marguerite Arp-Hagenbach,
Inv. 1968.407. Gift of Marguerite Arp-
Hagenbach. Photo: Martin Bühler

25 (p. 73)
Hoffmanneske Märchenscene, 1921
Hoffmannesque Fairy-Tale Scene
colour lithograph on paper
35.5 x 26.1 cm
1921-123
Solomon R. Guggenheim Museum,
New York
73.2029
Photo: Lee B. Ewing
Photo © The Solomon R. Guggenheim
Foundation, New York

26 (p. 69)
Das Pathos der Fruchtbarkeit, 1921
The Pathos of Fertility
printed transfer drawing and watercolour
on paper bordered with ink, mounted on
verso of lithograph by Paul Rohrbach
37.8 x 30.5 cm
1921-130
The Metropolitan Museum of Art, The
Berggruen Klee Collection, 1984

27 (p. 65)
Ein Tisch mit seltsamer Flora besetzt, 1921
Strange Flora Set on a Table
pencil on lining paper mounted on card
28.5 x 22 cm
1921-150
Private Collection

28 (p. 64)
Die Knospe des Lächelns, 1921
The Bud of the Smile
graphite on paper mounted on card
28 x 16.5 cm
1921-159
Extended loan of the Carl Djerassi Trust
II to the San Francisco Museum of
Modern Art
Photo: Ben Blackwell

29 (p. 68)
*Zeichnung zum 'Pathos der
Fruchtbarkeit'*, 1921
Drawing for 'The Pathos of Fertility'
pencil on wove paper mounted on card
28.1 x 22 cm
1921-170
Norton Simon Museum, Pasadena, CA,
The Blue Four Galka Scheyer Collection,
1953

30 (p. 40)
Städtebild (rot/grüne Accente), 1921
Picture of a City (Red-Green Accents)
oil on plaster-primed gauze bordered
with gouache, mounted on card
42 x 42.5 cm
1921-175
Staatsgalerie Stuttgart, permanent loan

31 (p. 67)
Seltsame Pflanzen, 1921
Strange Plants
pencil on paper mounted on card
22.6 x 28.3 cm
1921-203
Kunstsammlung Nordrhein-Westfalen,
Düsseldorf
Photo: Walter Klein, Düsseldorf

32 (p. 99)
Der Bote des Herbstes, 1922
Harbinger of Autumn
watercolour and pencil on paper
bordered with watercolour and pen,
mounted on card
24.3 x 31.4 cm
1922-69
Yale University Art Gallery
Gift of the Collection Société Anonyme

33 (p. 50)
Abenteuer eines Fräuleins, 1922
Young Lady's Adventure
watercolour and pen on paper with
gouache and pen marginal stripes,
mounted on card
43.8 x 32.1 cm
1922-152
Tate. Purchased 1946
Photo © Tate, London 2001

34 (p. 66)
Pflanzlich-physiognomisch, 1922
Vegetable-Physiognomic
pencil on paper mounted on card
19.3 x 16.4 cm
1922-230
Paul-Klee-Stiftung, Kunstmuseum Bern
Photo: Peter Lauri, Bern

35 (p. 41)
Statisch-Dynamische Steigerung, 1923
Static-Dynamic Gradation
oil and gouache on wove paper bordered
with gouache, watercolour and ink,
mounted on cardboard
38.1 x 26.1 cm
1923-67
The Metropolitan Museum of Art, The
Berggruen Klee Collection, 1987

36 (p. 93)
Architektur der Ebene, 1923
Architecture of the Plain
watercolour and pencil on paper with
watercolour and pen marginal stripes,
mounted on card
28 x 17.3/18.1 cm
1923-113
Staatliche Museen zu Berlin.
Nationalgalerie. Sammlung Berggruen
Photo: Jens Ziehe
Photo © bpk, Berlin

37 (p. 70)
Nachtfaltertanz, 1923
Dance of the Moth
oil transfer drawing, pencil and
watercolour on paper with watercolour,
pen and gouache marginal stripes,
mounted on card
51.5 x 32.5 cm
1923-124
Aichi Prefectural Museum
of Art, Nagoya

38 (p. 94)
Seiltänzer, 1923
Tightrope Walker
lithograph
44 x 27.9 cm
1923-138
Centre Georges Pompidou, Paris / Musée
national d'art moderne
Bequest of Nina Kandinsky (Neuilly-sur-
Seine), 1981
© Photo CNAC/MNAM Dist. RMN
Photo: Service de documentation photo

39 (p. 95)
Ein Gleichgewicht-Capriccio, 1923
An Equilibrium Caprice
pen and ink on paper
22.8 x 30.8 cm
1923-201
The Museum of Modern Art, New York
A. Conger Goodyear Fund
93.50
Photo © 2002 The Museum of Modern
Art, New York

40 (p. 96)
Helldunkel-Studie (Staffeleilampe), 1924
Study in Chiaroscuro (Easel Lamp)
watercolour on paper mounted on card
30.5 x 23 cm
1924-23
Kunstsammlung Nordrhein-Westfalen,
Düsseldorf
Photo: Walter Klein, Düsseldorf

41 (p. 71)
Gebirgsbildung, 1924
Mountain Formation
oil transfer drawing, watercolour and
pencil on paper mounted on card
41.9 x 38.1 cm
1924-123
Staatsgalerie Stuttgart / Graphische
Sammlung

42 (p. 145)
Structural I, 1924
Structural I
gouache on card bordered with ink,
mounted on cardboard
28.6 x 14 cm
1924-125
The Metropolitan Museum of Art, The
Berggruen Klee Collection, 1984

43 (p. 144)
Vorhang, 1924
Curtain
watercolour on madder-and-glue primed
linen bordered with watercolour,
mounted on card, 18.1 x 9.2 cm
1924-129b
Solomon R. Guggenheim Museum,
New York
Hilla Rebay Collection, 1971
71.1936.R115
Photo: David Heald
Photo © The Solomon R. Guggenheim
Foundation, New York

44 (p. 150)
Blumen Garten, 1924
Flower Garden
black paste ground, gouache, and incising
on paper mounted on card
35 x 20.3 cm
1924-131
The Museum of Modern Art, New York
Katherine S. Dreier Bequest
166.53
Photo © 2002 The Museum of Modern
Art, New York

45 (p. 152)
reife Ernte, 1924
Ripe Harvest
indian ink and watercolour on paper
mounted on card
22.7 x 12.8 cm
1924-172
Sprengel Museum Hannover
Photo: Michael Herling

46 (p. 143)
ARA "Kühlung in einem Garten der heissen Zone", 1924
ARA "Cooling in a Garden of the Torrid Zone"
pen and watercolour on paper mounted on card
29.6 x 20.7 cm
1924-186
Öffentliche Kunstsammlung Basel, Kupferstichkabinett, Endowment Richard Doetsch-Benziger, Inv. Nr. 1960.60
Photo: Martin Bühler

47 (p. 151)
Gartenbau, 1925
Horticulture
pen on paper mounted on card
14.5 x 18.5 cm
1925-164 (G4)
Private Collection

48 (p. 42)
Alter Klang, 1925
Ancient Harmony
oil on card
38 x 38 cm
1925-236 (X6)
Öffentliche Kunstsammlung Basel, Kunstmuseum
Richard Doetsch-Benziger Bequest, Basel 1960
Photo: Öffentliche Kunstsammlung Basel, Martin Bühler

49 (p. 116)
Felsen Tempel, 1925
Rock-Cut Temple
pen on paper mounted on card
16.5 x 27 cm
1925-251 (Z1)
Fondazione Antonio Mazzotta, Milan

50 (p. 110)
Waldarchitectur, 1925
Forest Architecture
pen and watercolour on paper mounted on card
31 x 21 cm
1925-251 (Z1) – duplicate number
Private Collection
Photo: P. Trawinski

51 (p. 113)
Schloss im Wald zu bauen, 1926
Castle to be Built in the Woods
watercolour and opaque white on primed paper bordered with pen and gouache, mounted on card
24.8 x 38 cm
1926-2
Staatsgalerie Stuttgart / Graphische Sammlung

52 (p. 109)
Ansicht eines Berg-Heiligtums, 1926
View of a Mountain Sanctuary
indian ink and watercolour on paper mounted on card
47 x 30 cm
1926-18 (K8)
Sprengel Museum Hannover
Photo: Michael Herling

53 (p. 112)
Garten des Ordens, 1926
Garden of the Order
pen and watercolour on paper mounted on card
21.9 x 12.1 cm
1926-21 (L1)
Private Collection
Photo: Robert E. Mates

54 (p. 123)
Fische im Wildbach, 1926
Fishes in the Torrent
pen on paper mounted on card
13.2 x 17.5/17.3 cm
1926-51 (O1)
Private Collection Cologne
Photo: Klee-Gesellschaft

55 (p. 86)
"sichtbar machen", 1926
"make visible"
pen on paper mounted on card
11 x 30.3 cm
1926-66 (P6)
Gift of LK, Klee-Museum, Bern
Photo: Peter Lauri, Bern

56 (p. 75)
barbarisch-klassisch-festlich, 1926
Barbarian-Classical-Festive
watercolour and ink on paper
mounted on card
29 x 30.8 cm
1926-69 (P9)
Staatliche Museen zu Berlin.
Nationalgalerie. Sammlung Berggruen
Photo: Jens Ziehe, 1997
Photo © bpk, Berlin

57 (p. 146)
Jungwaldtafel, 1926
Tablet of the Young Wood
oil and incising on plaster-primed muslin
mounted on card
35 x 25.5 cm
1926-208 (U8)
Staatsgalerie Stuttgart

58 (p. 147)
"Florentinisches" Villen Viertel, 1926
"Florentine" Residential District
oil on cardboard
49.5 x 36.5 cm
1926-223 (W3)
Centre Georges Pompidou, Paris / Musée
national d'art moderne
Purchased 1970
© Photo CNAC/MNAM Dist. RMN
Photo: Service de documentation photo

59 (p. 148)
Pastorale (Rhythmen), 1927
Pastorale (Rhythms)
tempera on canvas mounted on wood
69.3 x 52.4 cm
1927-20 (K10)
The Museum of Modern Art, New York,
Abby Aldrich Rockefeller Fund and
exchange, 1945
Photo © 2002 The Museum of Modern
Art, New York

60 (p. 155)
Segelschiffe, leicht bewegt, 1927
Sailing Boats, Gently Moving
pen on paper mounted on card
30.5 x 46.3 cm
1927-149 (E9)
Private Collection Switzerland
Photo: Peter Lauri, Bern
not in exhibition

61 (p. 156)
Härten in Bewegung, 1927
Hardnesses in Motion
chalk on paper mounted on card
20.9 x 33.1 cm
1927-214 (V4)
Private Collection Switzerland
Photo: Peter Lauri, Bern

62 (p. 154)
Drohender Schneesturm, 1927
Threatening Snowstorm
pen, ink and watercolour on paper
mounted on card
49.9 x 31.6 cm
1927-291 (Omega 1)
Scottish National Gallery of Modern Art,
Edinburgh
Bequeathed by Miss Anna G. Blair in
memory of Mr R.K. Blair 1952
Photo: Antonia Reeve Photography

63 (p. 72)
Zauber Kunst Stück, 1927
Conjuring Trick
oil on cloth mounted on board
49.7 x 41.7 cm
1927-297 (Omega 7)
Philadelphia Museum of Art: The Louise
and Walter Arensberg Collection, 1950
Photo: Graydon Wood, 1988

64 (p. 149)
Ein Blatt aus dem Städtebuch, 1928
A Leaf from the Book of Cities
tempera and oil on paper mounted
on card
42.5 x 31.5 cm
1928-46 (N6)
Öffentliche Kunstsammlung Basel,
Kunstmuseum
Photo: Öffentliche Kunstsammlung
Basel, Martin Bühler

65 (p. 128)
Bildnis Frau Gl., 1929
Portrait of Mrs Gl.
watercolour and pen on paper mounted
on card
45.7 x 30.5 cm
1929-39 (M9)
Öffentliche Kunstsammlung Basel,
Kupferstichkabinett, Endowment Klee-
Gesellschaft, Bern, Inv. 1948.109

66 (p. 126)
Ordensburg, 1929
Castle of the Order
pen on paper mounted on card
29.5/28.5 x 24.6/24.3 cm
1929-51 (O1)
Paul-Klee-Stiftung, Kunstmuseum Bern
Photo: Peter Lauri, Bern

67 (p. 127)
Rechnender Greis, 1929
Old Man Reckoning
etching, A.P., ed. 125
29.7 x 23.7 cm

1929-99 (S9)
Extended loan and promised gift of the
Carl Djerassi Trust I to the San Francisco
Museum of Modern Art
Photo: Ben Blackwell

68 (p. 74)
Nichtcomponiertes im Raum, 1929
Uncomposed in Space
watercolour, pen, chalk and pencil on
paper mounted on card
31.7 x 24.5 cm
1929-124 (C4)
Private Collection Switzerland
Photo: Peter Lauri, Bern

69 (p. 91)
Feigenbaum, 1929
Fig Tree
watercolour on paper
28 x 20.8 cm
1929-240 (X10)
Private Collection

70 (p. 119)
Fluten, 1929
Floods
pen on paper mounted on card
11.6/12.4 x 30 cm
1929-287 (UE7)
Private Collection Switzerland
Photo: Peter Lauri, Bern

71 (p. 122)
Schöpfer II, 1930
Creator II
oil transfer drawing on printing paper
mounted on card
36.8 x 47 cm
1930-35 (M5)
Judy and Michael Steinhardt Collection,
New York
Photo © Sarah Wells 1998

72 (p. 88)
Räumliche Studie I (rationale Verbindungen), 1930
Spatial Study I (Rational Connections)
pencil and chalk on paper mounted on card
37.5/37.8 x 46.7 cm
1930-109 (U9)
Paul-Klee-Stiftung, Kunstmuseum Bern
Photo: Peter Lauri, Bern

73 (p. 157)
Familienspaziergang, 1930
Family Walk
pen and watercolour on paper mounted on card
39.7/40.1 x 57.5 cm
1930-260 (J10)
Paul-Klee-Stiftung, Kunstmuseum Bern
Photo: Peter Lauri, Bern

74 (p. 89)
Beschwingtes, 1931
Elated
pen and pencil on paper mounted on card
21 x 33 cm
1931-72 (M12)
Öffentliche Kunstsammlung Basel, Kupferstichkabinett, Endowment Klee Gesellschaft, Bern, Inv. 1948.111
Photo: Martin Bühler

75 (p. 90)
L'homme approximatif, 1931
The Approximate Man
etching and drypoint, proof, ed. 10
17.8 x 14 cm
1931-157 (R17)
Extended loan and promised gift of the Carl Djerassi Trust I to the San Francisco Museum of Modern Art
Photo: Ben Blackwell

76 (p. 132)
Kreuze und Säulen, 1931
Crosses and Columns
watercolour on paper mounted on card

38 x 53 cm
1931-184 (T4)
Bayerische Staatsgemäldesammlungen, Staatsgalerie moderner Kunst
Photo: Blauel/Gnamm - Artothek

77 (p. 129)
Zwei betonte Lagen, 1932
Two Accented Layers
gouache and watercolour on Ingres paper mounted on card
24.8 x 30.4 cm
1932-6
The Menil Collection, Houston
Photo: Hester+Hardaway, Houston

78 (p. 130)
Reflexe im Dunkeln, 1932
Reflections in the Dark
watercolour on paper
30.6 x 24.2 cm
1932-8 (8)
Staatsgalerie Stuttgart / Graphische Sammlung

79 (p. 131)
Frühlingsbild, 1932
Spring Painting
watercolour on paper
26.3 x 47.9 cm
1932-65 (M5)
Private Collection Switzerland
Photo: Martin Bühler

80 (p. 92)
Zwei Gänge, 1932
Two Ways
watercolour on paper mounted on paper
31.3 x 48.4 cm
1932-236 (V16)
Solomon R. Guggenheim Museum, New York
48.1172.x139
Photo: David Heald
Photo © The Solomon R. Guggenheim Foundation, New York

81 (p. 97)
Spiralschraubenblüten II, 1932
Helical Flowers II
watercolour and pencil on paper mounted
on card
37.4 x 48.3 cm
1932-238 (V18)
Sprengel Museum Hannover, on loan
from Stiftung Sammlung Bernhard
Sprengel and the Friends of the Sprengel
Museum Hannover
Photo: Michael Herling

82 (p. 114)
Einsame Blüte, 1934
Lonely Flower
watercolour, pen and ink on paper
47.8 x 31.5 cm
1934-5 (5)
Columbus Museum of Art, Ohio
Gift of Howard D. and Babette L. Sirak,
the Donors to the Campaign for
Enduring Excellence, and the
Derby Fund
not in exhibition

83 (p. 118)
Felsenbild, 1934
Rock Picture
pencil on paper mounted on card
17.9 x 27 cm
1934-138 (QU18)
Private Collection Switzerland
Photo: Peter Lauri, Bern

84 (p. 117)
Kult-Stätte, 1934
Place of Worship
pen on paper mounted on card
11.6 x 27 cm
1934-141 (R1)
Private Collection Switzerland
Photo: Peter Lauri, Bern

85 (p. 120)
Quelle im Strom, 1934
Spring in the Stream
chalk on paper mounted on card
17.9 x 27 cm
1934-167 (S7)
Gift of LK, Klee-Museum, Bern
Photo: Peter Lauri, Bern

86 (p. 121)
Spiel auf dem Wasser, 1935
Play on the Water
pencil on paper mounted on card
17.9 x 27 cm
1935-3
Paul-Klee-Stiftung, Kunstmuseum Bern
Photo: Peter Lauri, Bern

87 (p. 168)
Geheime Schriftzeichen, 1937
Secret Letters
charcoal and white gesso on newspaper
mounted on card
48.5 x 33 cm
1937-2 (2)
Private Collection Switzerland

88 (p. 170)
Stolz I, 1937
Pride I
coloured paste and charcoal on brown
paper mounted on card
40 x 23.5/22 cm
1937-49 (L9)
Sprengel Museum Hannover, on loan
from Stiftung Sammlung Bernhard
Sprengel and the Friends of the Sprengel
Museum Hannover
Photo: Michael Herling

89 (p. 171)
Pathos II, 1937
charcoal on dyed cotton mounted on
cardboard
48.1 x 32 cm
1937-76 (M16)
Centre Georges Pompidou, Paris / Musée
national d'art moderne
Donation Louise and Michel Leiris
(Paris), 1984
© Photo CNAC/MNAM Dist. RMN
Photo: Philippe Migeat

90 (p. 169)
Niesen-Landschaft, 1937
Niesen Landscape
distemper on wove paper
35.5 x 27.5 cm
1937-231 (V11)
Private Collection

91 (p. 175)
Die Vase, 1938
The Vase
oil on burlap mounted on burlap
88 x 54.5 cm
1938-122 (J2)
Fondation Beyeler, Riehen/Basel
not in exhibition

92 (p. 172)
Zerbrochener Schlüssel, 1938
The Broken Key
oil on burlap
50 x 66 cm
1938-136 (J16)
Sprengel Museum Hannover
Photo: Michael Herling

93 (p. 174)
Ein Kinderspiel, 1939
A Children's Game
coloured paste and watercolour on
cardboard
43.5 x 32 cm
1939-385 (A5)
Staatliche Museen zu Berlin.
Nationalgalerie. Sammlung Berggruen
Photo: Jens Ziehe
Photo © bpk, Berlin

94 (p. 173)
Umgriff, 1939
Hold
oil, watercolour and coloured paste on
Ingres paper mounted on card
23.5 x 31 cm
1939-1121 (JK1)
Sprengel Museum Hannover
Photo: Michael Herling

95 (p. 176)
Feinarbeit, 1940
Fine Work
crayon on paper mounted on card
21 x 29.6 cm
1940-106 (U6)
Paul-Klee-Stiftung, Kunstmuseum Bern
Photo: Peter Lauri, Bern

96 (p. 165)
Wander-Artist (ein Plakat), 1940
Wandering Artist (a Poster)
coloured paste on paper mounted on card
31 x 29.2 cm
1940-273 (L13)
Private Collection Switzerland
Photo: Peter Lauri, Bern
not in exhibition

LENDERS TO THE EXHIBITION

France
Centre Georges Pompidou / Musée
 national d'art moderne, Paris

Germany
Bayerische Staatsgemäldesammlungen,
 Munich
Kunstsammlung Nordrhein-Westfalen,
 Dusseldorf
museum kunst palast, Dusseldorf
Sprengel Museum Hannover
Staatliche Museen zu Berlin.
 Nationalgalerie. Sammlung Berggruen
Staatsgalerie Stuttgart
Staatsgalerie Stuttgart/Graphische
 Sammlung
Städtische Galerie im Lenbachhaus,
 Munich
Städtische Galerie im Städelschen
 Kunstinstitut, Frankfurt

Israel
The Israel Museum, Jerusalem

Italy
Fondazione Antonio Mazzotta, Milan

Japan
Aichi Prefectural Museum of Art, Nagoya

Switzerland
Fondation Beyeler, Riehen/Basel
Öffentliche Kunstsammlung Basel,
 Kunstmuseum und Museum für
 Gegenwartskunst
Öffentliche Kunstsammlung Basel,
 Kupferstichkabinett
Paul-Klee-Stiftung, Kunstmuseum Bern

UK
Scottish National Gallery of Modern Art,
 Edinburgh
Tate, London

USA
Carl Djerassi
Columbus Museum of Art, Ohio
Judy and Michael Steinhardt Collection,
 New York
The Menil Collection, Houston
The Metropolitan Museum of Art, New
 York
The Museum of Modern Art, New York
Norton Simon Museum, Pasadena
Philadelphia Museum of Art
San Francisco Museum of Modern Art
Solomon R. Guggenheim Museum, New
 York
Yale University Art Gallery, New Haven

and those lenders who wish to remain anonymous